DORLING KINDERSLEY ▣◩ EYEWITNESS BOOKS

WATERCOLOR

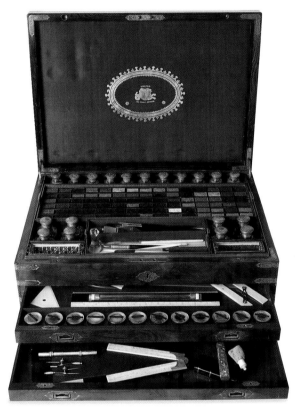

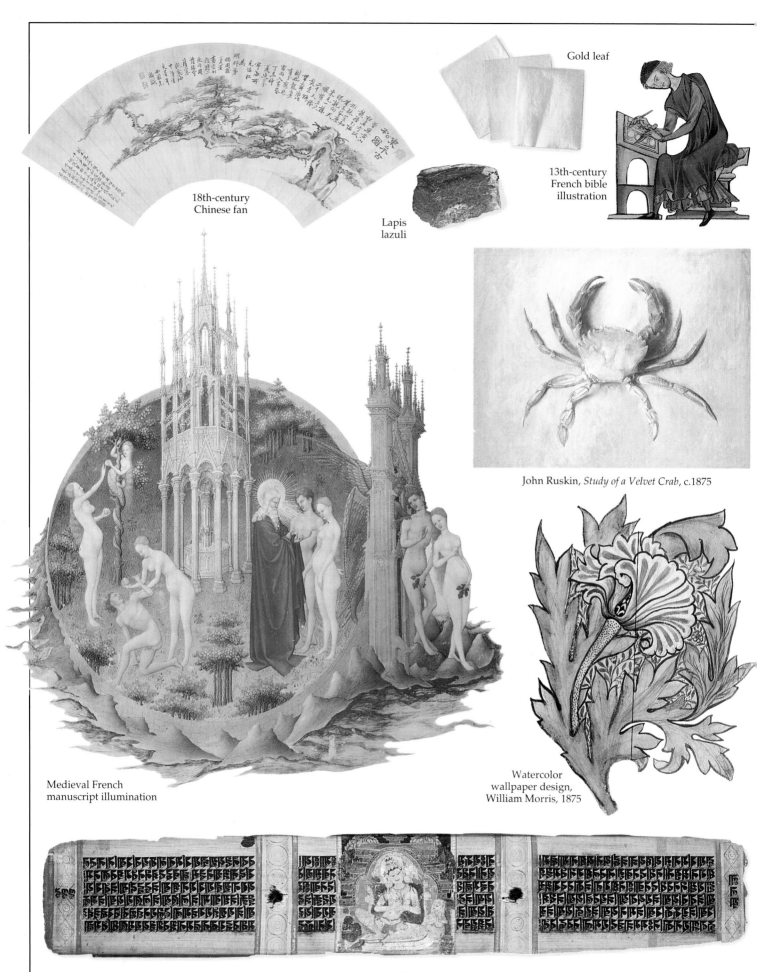

18th-century
Chinese fan

Gold leaf

Lapis
lazuli

13th-century
French bible
illustration

John Ruskin, *Study of a Velvet Crab*, c.1875

Medieval French
manuscript illumination

Watercolor
wallpaper design,
William Morris, 1875

12th-century Indian manuscript

DK EYEWITNESS BOOKS

WATERCOLOR

MICHAEL CLARKE

Book illustrations
by William Blake

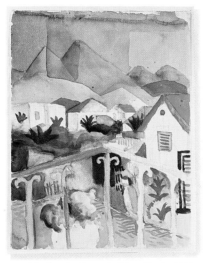

August Macke, *St. Germain, Near Tunis*, 1914

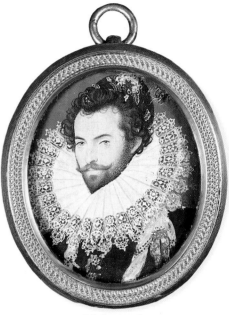

Miniature of
Sir Walter Raleigh

Silk fan design
by Camille
Pissarro, 1885

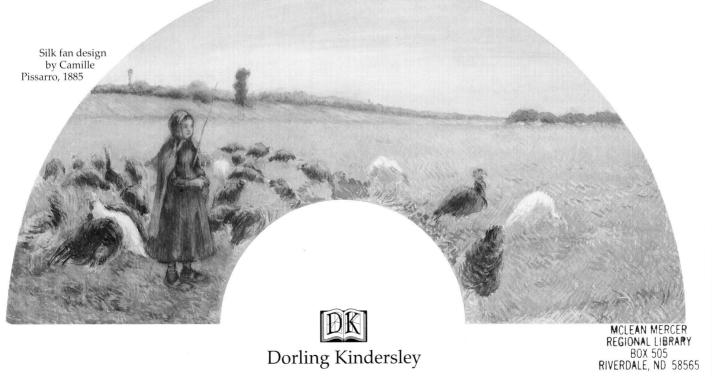

DK

Dorling Kindersley

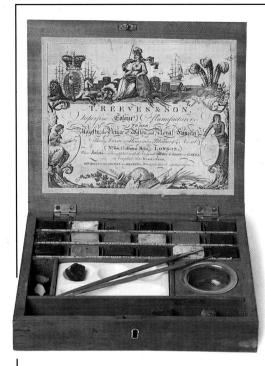

Watercolor box,
produced between
1766 and 1783

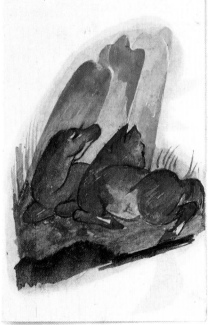

Franz Marc, *Two Blue Horses
in Front of a Red Rock*, 1913

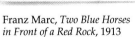

Gum
arabic

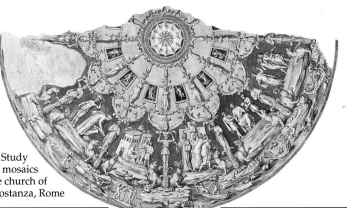

Study
of mosaics
in the church of
Santa Costanza, Rome

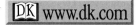

DK

Dorling Kindersley
LONDON, NEW YORK, AUCKLAND, DELHI,
JOHANNESBURG, MUNICH, PARIS and SYDNEY

For a full catalog, visit

DK www.dk.com

Editors Helen Castle and Ann Kay
Designer Claire Pegrum
Picture researcher Jo Evans
Editorial researcher Peter Jones
Design assistant Simon Murrell
Senior editor Gwen Edmonds
Senior art editor Toni Kay
Managing editor Sean Moore
Managing art editor Tina Vaughan
US editor Laaren Brown
DTP designer Doug Miller
DTP manager Joanna Figg-Latham
Production controller Meryl Silbert

This Eyewitness ® Book has been conceived by
Dorling Kindersley Limited and Editions Gallimard

Published in the United States by
Dorling Kindersley Publishing, Inc.
95 Madison Avenue
New York, NY 10016
2 4 6 8 10 9 7 5 3 1

Dorling Kindersley books are available at special discounts for bulk purchases
for sales promotions or premiums. Special editions, including personalized
covers, excerpts of existing guides, and corporate imprints can be created in
large quantities for specific needs. For more information, contact Special
Markets Dept., Dorling Kindersley Publishing, Inc., 95 Madison Ave.,
New York, NY 10016; Fax: (800) 600-9098

Library of Congress Cataloging-in-Publication Data
Clarke, Michael, (1952-)
Watercolor / written by Michael Clarke.
p. cm. — (Eyewitness Books)
Includes index.
1. Watercolor painting. I. Title. II. Series.
ND2130.C63 2000
751. 42′2—dc20 92-54547
 CIP
ISBN 0-7894-6177-3 (pb) ISBN 0-7894-5584-6 (hc)

Color reproduction by Colourscan, Singapore
Printed in China by Toppan Printing Co. (Shenzahen) Ltd.

The pigment-
producing
mineral,
cinnabar

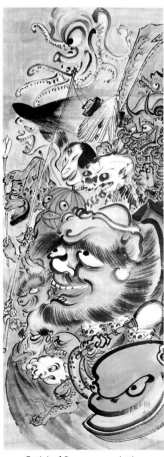

Miniature of
Elizabeth I

Satirical Japanese painting,
late 19th century

Contents

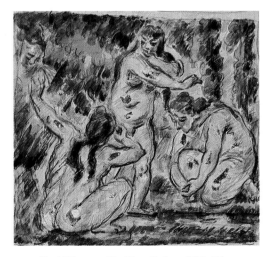

Paul Cézanne, *The Three Bathers*, 1874–75

What is watercolor?

IN ITS BROADEST SENSE, WATERCOLOR is any paint that is water-based – as opposed to being oil-based. The essential ingredients of watercolor are pigments (the substances that provide the colors), a binding agent (usually gum arabic), and water. When combined, these three components create transparent watercolor. However, if substances such as lead white (p. 62) are added, the watercolor becomes opaque. This opaque color is called gouache or bodycolor (p. 62), and many of the paintings in this book are a mixture of transparent and opaque watercolor. Whatever the type of watercolor, the technique remains similar. Paint is thinned with water before being applied to a surface. Having spread the color, the water evaporates, leaving pigment bound to the surface by the gum. When struck by light, the pigment gives off color. Today, watercolors are usually painted on paper. Ancient civilizations such as the Egyptians, the Greeks, and the Romans, however, painted onto walls. In the Far East, silk was used, and medieval artists painted on parchment. Paper was invented in China and had become common in Europe by the 16th century. (*Unless otherwise stated, all watercolor works in this book are on paper.*)

CAVE PAINTING
Prehistoric watercolors, such as those used in this 20,000-year-old example, were made from berries or minerals (color), saliva (binding), and water. This is from Pech-Merle, France.

Cinnabar

Saffron

PIGMENTS
Pigments are either organic (vegetable, animal), like saffron, which is from a type of crocus, or inorganic (mineral), like cinnabar.

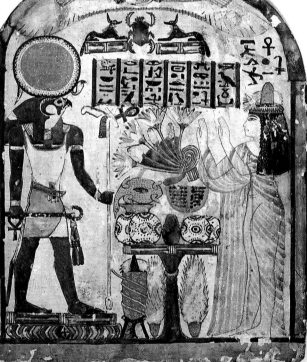

THE PAINTINGS OF THE PHARAOHS
Many Egyptian watercolor paintings have survived since ancient times, protected in enclosed tombs. The paintings were often applied straight onto the mud-plaster walls of the tombs. The one above, however, was painted onto an upright wooden slab in c.1250 B.C. On the right, it shows Deniu-en-Khons, a musician priestess, making an offering to the god Re-Harakhty. The paint is a type of tempera, made out of an opaque watercolor bound with gum or egg white.

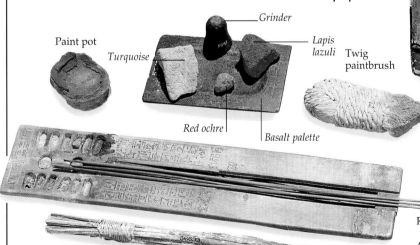

Paint pot

Turquoise

Grinder

Lapis lazuli

Twig paintbrush

Red ochre

Basalt palette

Twig paintbrush

Reed pens and palette

Palette

ANCIENT EGYPTIAN TOOLS *left*
The sophisticated range of tools developed by the Egyptians helps to explain their painting methods. The grinder and palette (c.1250 B.C.) were used to prepare paint. Minerals – such as the red ochre, lapis lazuli, and turquoise shown here – would have been ground down to produce pigments. These pigments would then have been mixed with a binding agent and water on a palette, or in a paint pot, and applied to a surface with broad twig brushes or finer reed pens.

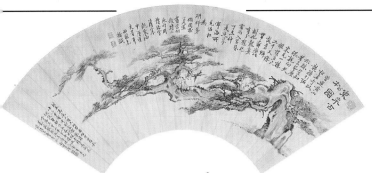

CHINESE FAN *above*

The tradition of Chinese watercolor painting dates back over 2,000 years and is usually associated with the use of soft, transparent washes. However, gouache and precious metals were introduced in the 16th century, when a sophisticated tradition of portrait painting started to develop. Watercolors were applied to a variety of surfaces, including silk, paper, and vellum. This fan, which was painted in 1727 by Gao Fengham, is a combination of watercolor and ink on paper. Fan-painting became particularly popular in China in the 18th and 19th centuries. (*See p. 19 for more details about this fan.*)

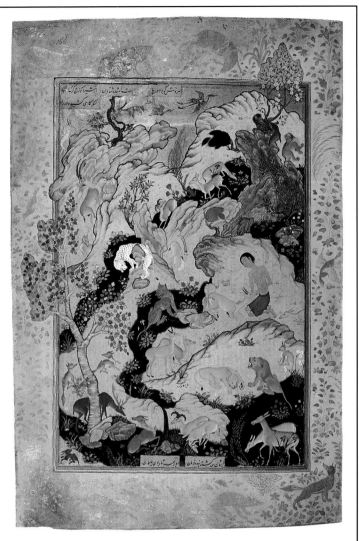

A PERSIAN MANUSCRIPT *right*

This illustration to Shah Tahmasb's *Nizami Manuscript* shows the rich color effects achieved by the use of gouache, an opaque watercolor, as opposed to simple transparent washes. The painting technique of Persian texts was intricate. It was also, in contrast to the use of washes, a gradual process of building up gouache and overlaying colors. The most precious of pigments, such as lapis lazuli, were even sorted grain by grain before application. (*See p. 18 for more details about this manuscript.*)

GUM ARABIC – THE BINDING AGENT

Gum arabic is taken from the sap of the acacia tree and is the normal binding agent in watercolor. It ensures the even dispersal of paint and an overall consistency of color – by generally darkening tones. Gum arabic has a tendency to harden, so substances such as honey and glycerine are added to moisten it. Extra glycerine is needed in hot, dry countries. One 18th-century artist, Paul Sandby, working in Britain's cold climate, added gin to speed up the drying process.

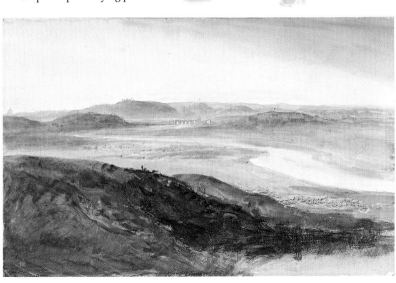

Modern cake of watercolor

Cake paint applied to paper

19th-century cake-mold

Tubes of watercolor that are available today

TURNER – A MASTER OF THE WESTERN TRADITION

The pale washes of Turner's *View of the Campagna, Italy* (1819) contrast with the rich gouache of the Persian manuscript above. Although Turner used gouache in many of his paintings, he tended to emphasize the watery and spontaneous qualities of watercolor. He soaked the paper beforehand so that the paint ran freely. He also created lighter areas by various methods, including rubbing the desired areas with wax. This wax repelled the watercolor and was later removed to reveal white, unpainted paper. (*See p. 36 for more details about this painting.*)

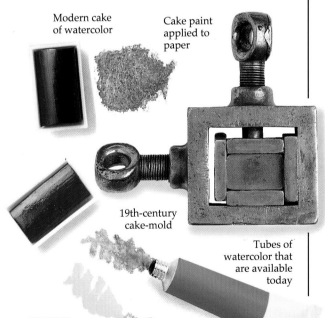

MODERN MATERIALS

Watercolor cakes were first manufactured in the late 1700s, from pigment, gum arabic, and preservative. In 1846, Winsor & Newton started to produce watercolor in tubes – a moister form of paint.

The variety of watercolor

WATERCOLOR HAS A LONG, varied history, which it owes to its unique versatility. Centuries of artists have exploited the fact that the medium creates vivid colors, and is both fast-drying and portable. Most of the works shown here were never intended to be "fine art." Early maps were often decorated with watercolor, and many architectural and garden plans were worked out initially in watercolor, partly because drawn designs are easily visible through watercolor washes. Before photography, watercolor artists were vital members of foreign expeditions – this convenient medium was ideal for recording exotic plants and animals (p. 26). However, it was not until the 19th century that highly finished water-colors such as Cox's *Calais Pier* began to be produced mainly for exhibition.

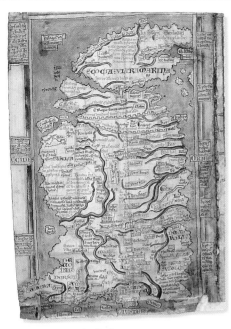

MAP OF GREAT BRITAIN
Matthew Paris; c.1250; ink and watercolor
Paris was a monk at the abbey of St. Albans near London, and one of the main chroniclers of 13th-century events. He often used watercolor illustrations in his writings, perhaps adding egg white to give adhesion. Watercolor is used to pick out the sea and the rivers in this early map of Britain.

THE MILITARY ROLL OF ARMS
English; before 1448; ink and bodycolor
These two jousting knights are from a manuscript containing over 160 scenes. The strong colors possible with bodycolor are well suited to the bright garments worn by medieval knights.

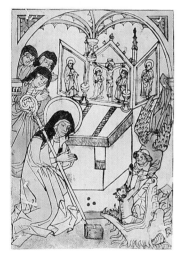

ST. OTTILIE
German (Swabian); c.1450; 10¼ x 7½ in (26 x 18.5 cm); watercolor added to a woodcut print
Woodcuts were the first printed images produced in the West. Simple watercolor washes add interest to the strong lines of this print.

Study of a Mosaic Dome, Santa Costanza, Rome
PIETRO SANTI BARTOLI
1690–99; 16¾ x 12¼ in (42.5 x 31 cm); pen and watercolor
Bartoli specialized in highly detailed engravings of Roman antiquities. This watercolor study for an engraving shows one half of a classical-style mosaic in the dome of the church of Santa Costanza. Originally a tomb, the building – and its mosaics – date from the fourth century.

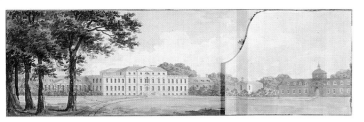

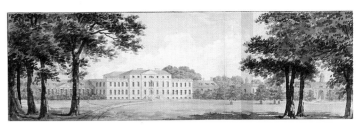

WIMPOLE HALL, BEFORE AND AFTER "IMPROVEMENT"
Humphry Repton; 1801; 8¼ x 19½ in (21 x 49.5 cm); watercolor

The late 18th and early 19th centuries saw the era of English country house park design. Humphry Repton (1752–1818), a successful landscape gardener, was noted for showing accomplished watercolor designs to his clients. He presented these designs, along with notes, in book form – known as "Red Books" because they were bound in soft red leather. Special flaps (called "slides" by Repton) were a feature of his watercolor designs. The two photographs above are of the same watercolor – taken from Repton's Red Book on Wimpole Hall. In the left-hand photograph, the flap is down, giving a view of the front entrance of the hall before Repton's intended alterations. In the right-hand photograph, the flap has been lifted to reveal how Wimpole would look after the changes. Repton proposed to plant trees to mask the red stable buildings on the right, which he considered ugly.

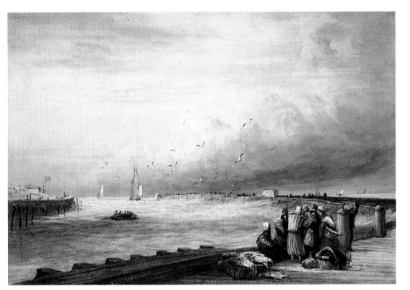

CALAIS PIER *left*
David Cox; 1828; 6½ x 10¾ in (16.5 x 27.5 cm); watercolor

In Britain, the great age of watercolor was in the first half of the 19th century, and Cox (1783–1859) was one of the era's most successful artists. Watercolors of the scope and ambition of *Calais Pier* were intended to rival, if not surpass, oil paintings. Cox's technique here, with its broken touches of strong coloring, is almost Impressionist in effect. The dramatic subject of Calais Pier was a favorite with Cox, and he painted it on a number of occasions. In his *Treatise on Landscape Painting and Effect in Watercolors* (1841), he wrote: "Every tint should be laid on with clearness and decision ..."

Delicate washes of color suggest fragile rose petals —

ROSE (*ROSA DAMASCENA*) *right*
Pierre-Joseph Redouté; 1817; watercolor

Redouté was probably the greatest plant illustrator of his time, producing watercolors such as this one and volumes of colored prints. His subjects demanded astonishing precision and, during his career, he meticulously painted rare plants in the Royal Garden, Paris, and Kew Gardens, London.

DESIGN FOR DULWICH GALLERY *below*
Sir John Soane's architectural practice; 1811; 13 x 20½ in (33 x 52 cm); watercolor

By the late 18th century, making large numbers of architectural models had become costly, and architects were increasingly using watercolors to show clients some of the design stages. Soane did few watercolor illustrations himself; many were done by his assistant, J.M. Gandy. This gallery, in south London, was built in 1811–13.

One of a series of watercolor designs for the Dulwich Gallery

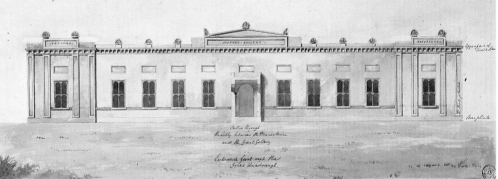

Illuminated texts

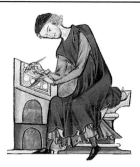

AN ARTIST AT WORK
This detail is from *A King and Queen ...* (p. 11). Most early medieval texts were produced by monks, and the text and pictures were usually executed by the same person.

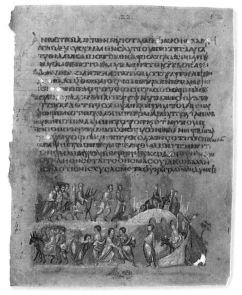

JACOB WRESTLING WITH THE ANGELS
Vienna Genesis Bible; c.700; 8¼ x 5 in (21 x 13 cm)
This image contains several scenes, all linked together pictorially. Like many opulent early manuscripts, it is painted on stained purple vellum – purple dye was highly expensive.

Iᴌʟᴜᴍɪɴᴀᴛᴇᴅ ᴍᴀɴᴜsᴄʀɪᴘᴛs – handmade books of text and pictures – were produced from later Roman times onward, reaching a peak during the Middle Ages. The paints used were opaque, but they consisted of ground pigments mixed with a binding agent and diluted with water – making these manuscripts the ancestors of modern-day watercolors. "Glair" (egg white) was the usual binding agent, although by the 14th century, gum arabic was more popular. Illuminated texts were written and painted on vellum or parchment (animal skin), and many medieval manuscripts were decorated with gold. Most of the texts were religious, although subjects such as the story of King Arthur, medical treatises, and Greek and Roman classics were also illustrated.

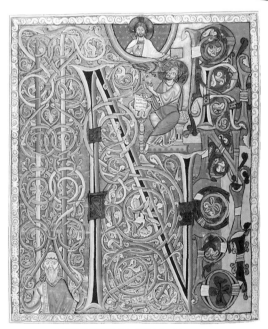

BEGINNING OF ST. JOHN'S GOSPEL
Arnstein Bible; 1175; 21½ x 14½ in (54.5 x 36 cm)
The opening words of the Proverbs and the Gospels were often illuminated. Here, St. John forms part of the initial letter. Later manuscripts such as this were more harmonious in color than early Christian texts.

St. John

LINDISFARNE GOSPEL *698; 13 x 10 in (34 x 25 cm)*
The spread of Christianity increased the need among missionaries for religious texts. This famous example was made on Lindisfarne ("holy island"), off the northeast coast of England. The yellowed animal skin on which it is painted is clearly visible.

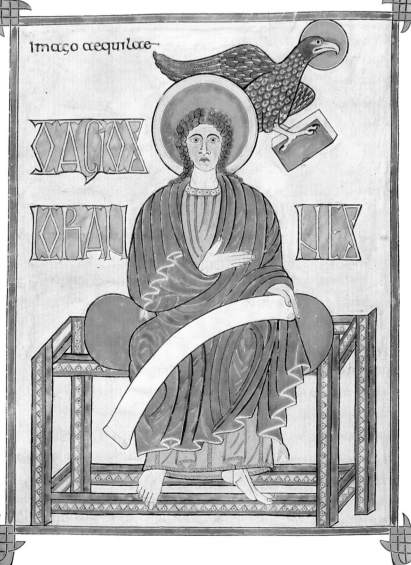

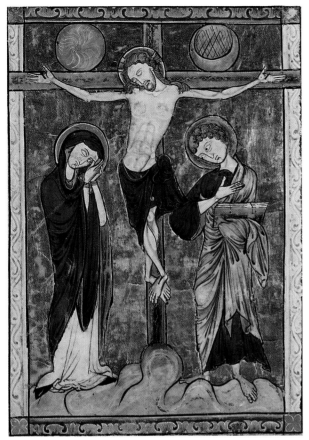

THE CRUCIFIXION
French Psalter; c.1215;
6¾ x 4¾ in (17 x 12 cm)
Brightly colored, with a substantial amount of expensive gold leaf, this illustration is from a Psalter, or Book of Psalms. Its rare and precious appearance is entirely intentional. In using expensive materials, the patrons of illuminated manuscripts not only honored the holy texts but also made a lavish display of their own devotion.

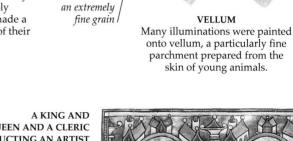

Vellum has an extremely fine grain

VELLUM
Many illuminations were painted onto vellum, a particularly fine parchment prepared from the skin of young animals.

A KING AND QUEEN AND A CLERIC INSTRUCTING AN ARTIST
Moralized Bible; Paris c.1220
This miniature is a fascinating depiction of patronage in the Middle Ages. A king and queen are shown above a cleric, who is instructing an artist how to write and paint. It was quite common for a patron's portrait to be included in a text.

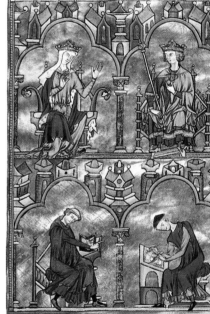

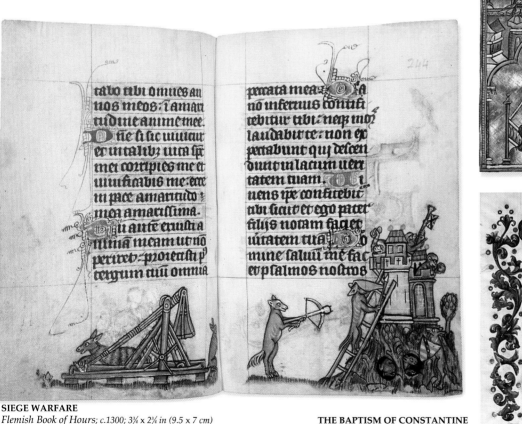

SIEGE WARFARE
Flemish Book of Hours; c.1300; 3¾ x 2¾ in (9.5 x 7 cm)
This is a marginal illustration from a tiny Book of Hours – a collection of religious texts intended for private use. Pictures were often placed in margins, as these were the less important parts of the manuscripts. Images were often deliberately amusing. Here, animals act the roles of men.

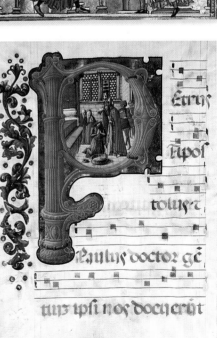

THE BAPTISM OF CONSTANTINE
Giovanni dei Corradi; 1451; 22 x 17 in (56 x 43 cm)
This scene is set in the initial "P" of the text. "Historiated" (containing a story) initials were common in illuminated manuscripts. Here, the text is set to music. The careful ruling of lines, so important in manuscript illumination, is also evident.

The Limbourgs

WIDELY ACKNOWLEDGED to be the greatest manuscript illuminators, the Limbourg brothers – Jean, Herman, and Paul – came from Nijmegen in what is now Holland. The brothers (all of whom, it seems, had died by 1416) were employed in the early 15th century by one of the most remarkable art patrons of the late Middle Ages – the French landowner Jean, Duke of Berry. For him, they painted some of the most beautiful and lavish of all illuminated manuscripts, such as the *Belles Heures* ("Beautiful Book of Hours") and the *Très Riches Heures* ("Very Rich Book of Hours"). Their work is possibly the most sophisticated predecessor of modern watercolor painting. To achieve the extraordinarily precise detail, the Limbourgs chose extremely fine brushes and probably used magnifying lenses.

PAUL LIMBOURG
The eldest brother's portrait appears on the January calendar page of the *Très Riches Heures* (below left).

CALENDAR
The *Très Riches Heures* begins with a spectacular series of full-page illustrations of the months of the year. Before each month is a page with that month's calendar written out. This is the calendar for October. The scribe's ruling lines are visible, and the page is decorated with richly colored foliate patterns. The colored pigments were mixed with water and gum – in addition to binding the pigment and making color adhere to the vellum, gum acted as an effective preservative.

The Très Riches Heures

THE LIMBOURG BROTHERS *1413–16 (left unfinished; completed by Jean Colombe c.1485); 206 bound sheets of fine vellum; each page: 11½ x 8¼ in (29 x 21 cm)*

Medieval "Books of Hours" contained Bible extracts and prayers for each hour of the day, and often included calendars. The paintings shown here all come from the *Très Riches Heures,* and represent the summit of the illuminator's art.

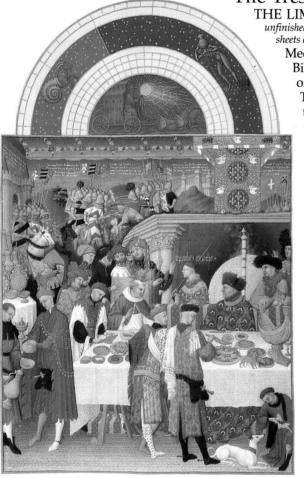

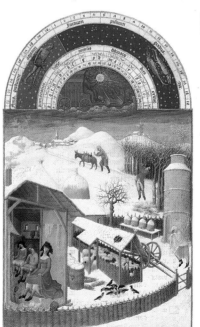

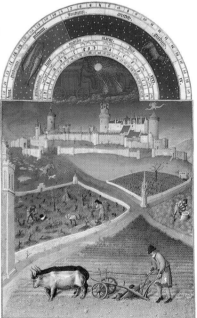

JANUARY *left*
Here, the Duke of Berry, wearing a hat, is seated at a table. The occasion shown is the day when seasonal gifts were traditionally exchanged and guests invited to dine. The vivid pigments used were obtained from minerals, plants, or chemicals.

FEBRUARY *right*
This month, frequently the hardest and bleakest of the year, has been captured with a vividly detailed realism. From the all-white landscape and the weak wintry light, to the leaden gray sky and the hungry birds pecking at the corn, nothing has escaped the artist's highly original observation. An amusingly coarse note is struck by the foreground figures, seen exposing their bodies to the warmth of the fire.

MARCH
Here, in the landscape overlooked by the Duke of Berry's château at Lusignan, the year's agricultural work begins. The brothers were masters of atmospheric perspective, whereby, as in this scene, forms tend to soften and lighten near the horizon.

OCTOBER

The Duke's Parisian residence, the Hôtel de Nesle, is shown in the background of this scene of plowing and sowing. The Limbourgs' landscapes were highly naturalistic, and the building is so precisely depicted that a model of it has been made, based on the details shown here.

GOLDS AND BLUES

The brothers fully exploited the richness of gold, either added to pigments and painted on, or as gold leaf, often glazed with green or red. Their skies, a deep, luminous, yet transparent blue, were painted in ultramarine, which was made from costly oriental lapis lazuli.

Gold leaf

Lapis lazuli

THE GARDEN OF EDEN

The Garden of Eden was placed a little farther along in the *Très Riches Heures*, after the illustrations of the months. It shows the story, told in the Book of Genesis, of the temptation and expulsion of Adam and Eve from the Garden of Eden. The figure type of Eve, with her swelling belly and graceful outlines, conforms to what was fashionable in northern Europe at the time. As in all their miniatures, the Limbourgs have made extensive use of gold leaf, even more so here than usual. Their placing of an essentially circular composition in the center of a rectangular page is particularly daring.

The architecture has a highly convincing three-dimensional realism

THE TEMPTATION

Eve takes the apple from the serpent and tempts Adam. Adam's and Eve's pale bodies stand out vividly against the strong green of the background.

THE EXPULSION

Adam and Eve pass through the gates of the Garden of Eden, banished from Paradise forever.

A transparent quality has been given to the water

Nature into art

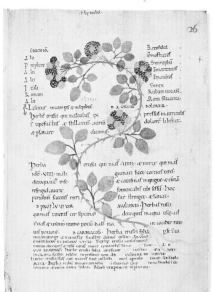

A BRAMBLE (*RUBUS FRUTICOSUS* **)**
English; c.1120; 10¼ x 7¾ in (26 x 20 cm);
pen and watercolor on vellum
This manuscript was produced in Bury St.
Edmunds, Suffolk. The bramble illustrates
a text – originally written about A.D. 400
– which describes herbal remedies derived
from plants. During the Middle Ages,
this type of knowledge was preserved in
religious institutions such as monasteries,
and this illustration was almost certainly
produced by a monk.

For CENTURIES, WATERCOLOR was the medium chosen for
making accurate plant and animal studies, and so played a part
in helping to advance scientific learning. Watercolor had been
used since medieval times to illustrate "herbals" – books that
described the properties of medicinal herbs. From the 15th
century onward, European explorers brought animal and plant
species from the Americas and the Far East back
to Europe (pp. 26–27). These were often recorded
in watercolor, which was both quick to apply
and fast-drying (specimens might decompose),
and allowed a high degree of detailed accuracy.

DETAILED DEPICTION
Painted studies of plants and animals had to
achieve the degree of detail later captured by
photographs – such as this picture of a bramble.

Painting the natural world

Nature studies were all basically stimulated by people's
desire to know as much as possible about the world they
inhabited. It was watercolor painters who often provided
the first accurate images of plants and animals from newly
explored lands (pp. 26–27). The illustrations on these pages
show a progression from essentially factual drawings to
studies that were very much works of art in their own right.

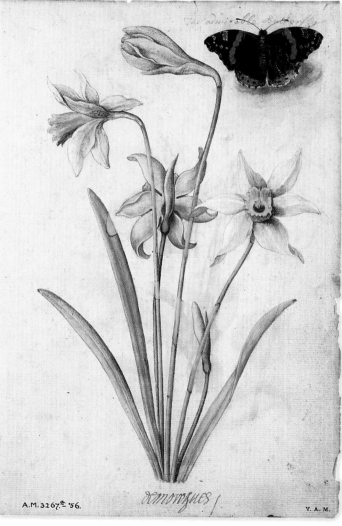

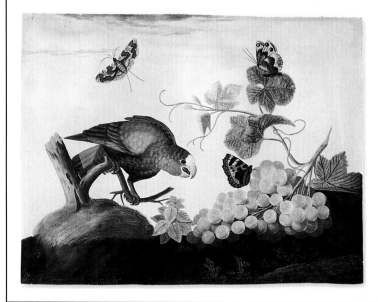

**A PARROT, BUTTERFLIES, MOTH,
AND MUSCADINE GRAPES**
Samuel Dixon; c.1755; 12 x 16 in
(30.5 x 40.5 cm); watercolor and bodycolor
Dixon's nature pieces – painted in
relatively thick color on embossed
paper – had a lifelike, almost three-
dimensional appearance. They were
highly popular in his native Dublin.

**DAFFODILS AND RED
ADMIRAL BUTTERFLY**
*Jacques Le Moyne de Morgues;
c.1586; 7½ x 11 in (19 x 27.5 cm);
watercolor and bodycolor*
Le Moyne painted flowers and
fruit seen in 16th-century English
gardens. He usually applied thin
watercolor washes over drawings,
adding very little bodycolor.

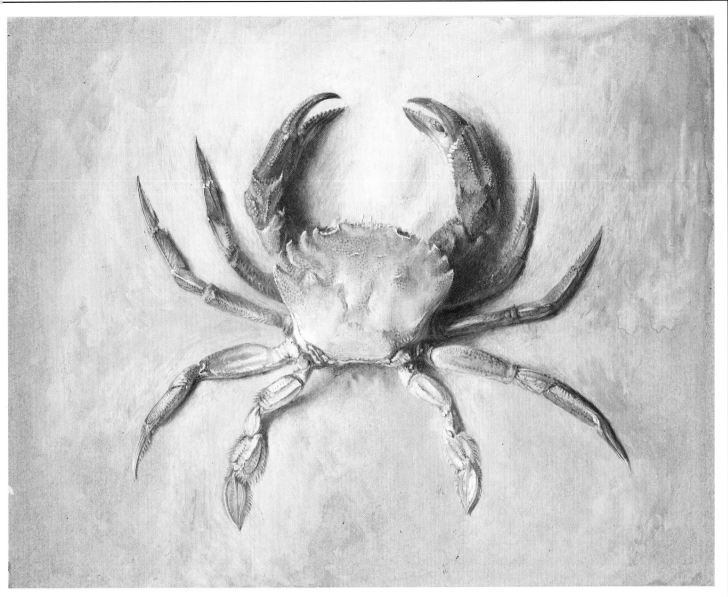

STUDY OF A VELVET CRAB
John Ruskin; c.1875; 9¾ x 12½ in
(24.5 x 31.5 cm); watercolor and bodycolor over pencil
The most influential English art critic of the 19th century, John Ruskin
(1819–1900) championed Turner (pp. 36–37), the Pre-Raphaelites (pp. 46–47),
and watercolor painting in general. He was a talented watercolorist himself,
and the precision of this piece recalls Dürer's nature studies (pp. 16–17).
Ruskin, a professor of art at Oxford, probably used it as a teaching aid.

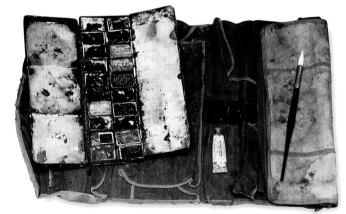

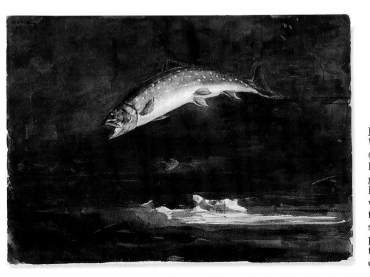

JUMPING TROUT
Winslow Homer; 1889; 12½ x 19½ in
(31.5 x 49.5 cm); watercolor and pencil
Homer (1836–1910) was one of the
greatest American watercolorists.
He fully exploited the qualities of
watercolor to express his love of
the sea and marine subjects. In this
superb drawing, he seems, almost
photographically, to have caught
the moment when the fish leaps
dramatically from the water.

HOMER'S WATERCOLOR BOX
These watercolor paints, in a
portable canvas pouch, were
used by Winslow Homer.
Homer obviously relished the
spontaneity of the medium – he
planned many of his fishing
trips so that he could combine
his twin passions of sketching
and angling. Detailed realism
was important: "I paint it [the
subject] exactly as it appears."

Watercolor's first master

ALBRECHT DÜRER (1471–1528) is often regarded as the first all-around master of watercolor. Almost half of his existing output was painted in the medium, and his technique was sophisticated for the time – he used pen and ink for outlines, opaque colors to show volume, and clear washes for light effects. Dürer would have seen many illuminated texts and colored woodcuts, but it was not until he started traveling that he filled his sketchbooks with washed drawings. In these, he was unrestrained by patrons' demands, and so chose to focus on landscapes and nature studies. In many ways, his inquiring approach to landscape anticipated the best of the great 19th-century watercolor tradition.

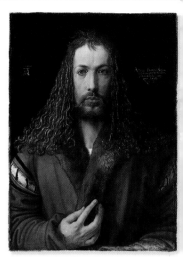

SELF-PORTRAIT
Albrecht Dürer; 1500; 67 x 49 in (170 x 124.5 cm); oil on canvas
"Thus I, Albrecht Dürer, from Nuremberg, painted myself with indelible colors at the age of 28." Dürer was by this time already a learned man. Having received a classical education, he was apprenticed to a painter, and then traveled widely. When in northern Italy, he was profoundly influenced by the art of the Italian masters.

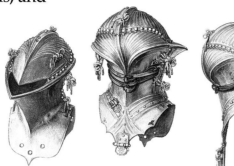

THREE STUDIES OF A HELMET
Albrecht Dürer; c.1500; original paper size: 16½ x 10½ in (42 x 27 cm); pen and watercolor
These tournament jousting helmets show the way in which Dürer mixed media. For instance, in the helmet on the right, he chose to sketch first in pen, before transferring to brushwork alone.

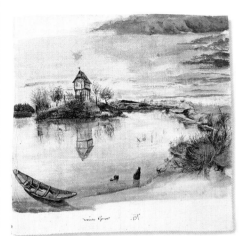

A HOUSE ON AN ISLAND IN A POND
Albrecht Dürer; 1496–97; 8¼ x 8¾ in (21.5 x 22 cm); watercolor and bodycolor
Dürer "discovered" the landscape watercolor, combining transparent and opaque colors to great atmospheric effect. This fisherman's house stood on the outskirts of Nuremberg, in Germany.

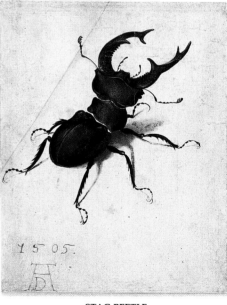

STAG BEETLE
Albrecht Dürer; 1505; 5½ x 4½ in (14 x 11.5 cm); watercolor and bodycolor
Dürer's many detailed watercolors of plants and animals effectively began the tradition of using watercolor for scientific drawings (pp. 14–15).

DÜRER'S DREAM (LANDSCAPE FLOODED WITH WATERS FROM HEAVEN)
Albrecht Dürer; 1525; 11¾ x 16½ in (30 x 42 cm); pen and watercolor
"In the night between Wednesday and Thursday after Whitsunday [May 30 to 31] I saw this appearance in my sleep ..." Dürer's watercolor sketch and handwritten text describe a cataclysmic rainstorm, which preceded a disastrous flood that had been widely prophesied in 1525.

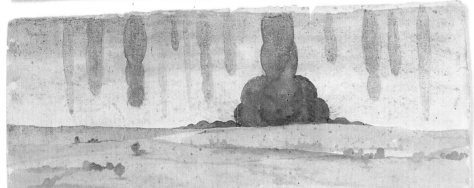

Val d'Arco: View of a Small Town with a Fortified Castle

ALBRECHT DÜRER *1495; 8¾ x 8¾ in (22.5 x 22.5 cm); watercolor and bodycolor*

This is one of Dürer's greatest landscape paintings. Its eerie luminosity was obtained by the use of various greens, laid one over the other, and by the blue-grays that distinguish the rock faces. He probably painted this when returning from his first visit to Italy. Although travel was inspiring for Dürer, it was also a necessity – in this period the plague raged through his native Nuremberg.

DETAIL OF A HILL TOWN
The acute powers of observation that Dürer often employed in his watercolors are well illustrated by this detail of a fortified hill town, set high up on a dramatic mountain crag. It is quite possible that Dürer himself would have stopped here for refreshment, or even a brief stay, on his homeward journey.

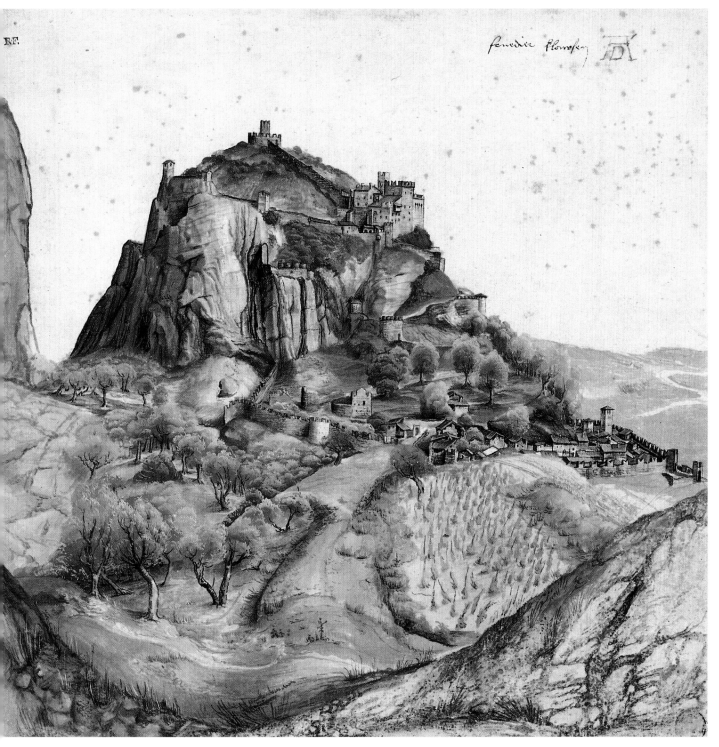

Eastern approaches

WATER-SOLUBLE PAINTS have been used throughout the Eastern world for many centuries – from the east coast of Africa, and the Middle East, to Japan. Equivalents of the modern watercolor were known in China during the first century B.C. About 2,000 years ago, Chinese artists began to paint watercolors onto screens and scrolls made of silk. It was the Chinese who invented the first paper, in A.D. 105, and Far Eastern artists who then perfected a technique of painting on both silk and paper with watercolors and ink. A strong landscape tradition developed in China, while the Japanese tended to choose more intimate subject matter – for example, in their 18th- and 19th-century drawings of actors and courtesans. In Persia (now Iran), the simple drawing and transparent washes of the 10th and 11th centuries were gradually replaced by richly decorated manuscripts, with intense, layered coloring.

ANIMALS AND THEIR USES *above Arabic; 13th century; 9½ x 6 in (24 x 15 cm); gouache and ink*
By the 13th century, Islamic workmanship had reached a high level of expertise. This illustration of a hare is from a work on the medicinal properties of parts of animals.

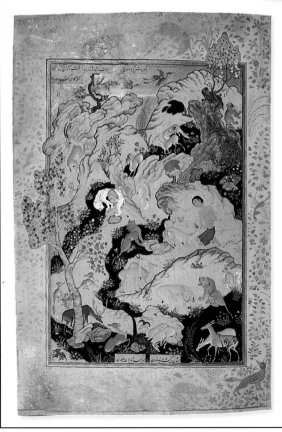

SHAH TAHMASB'S NIZAMI MANUSCRIPT *Persian; c.1540; 14 x 10 in (36 x 25 cm); ink, gouache, and gold leaf*
Shah Tahmasb commissioned this edition of the poems of Nizami, which was painted by various court artists. The strong outlines of the figures were first painted in with a reed pen or a fine brush. Opaque colors were then progressively overlaid, using glues or gum arabic for binding and brushes made from squirrel or kitten hairs, set in birds'-feather quills.

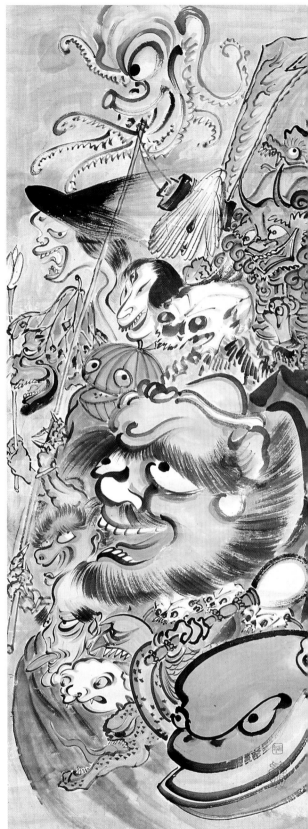

Nightmare of Demons & Chimera
KYOSAI *(Japanese) c.1885; 7 x 2 in (17 x 6 cm); ink and watercolor*
Kyosai appears to have painted this satirical, almost cartoonlike, work at great speed. He would lay on a wash with one brush while "diluting" the color on the paper with a second brush filled with water.

THE ANCIENT PINE OF DONG MON
*Gao Fengham (Chinese); 1727; maximum width:
21 in (53 cm); ink and watercolor on paper fan*
The painter belonged to a group known as the
Eccentric Masters of Yangzhou. He recalled
how pine trees in a certain area reminded
him of dragons: "I used to choose the
pines of Huangshan to paint the
unusual crouching dragons
stretching out in strange and
different shapes." Apart
from the main inscription
across the top, there
is another poem on
the left of the fan.

The delicately observed tree
displays the traditional
Chinese interest in
natural forms

*The tree is
shaped like
a dragon*

FANS IN THE WEST
The fan was a form that was
particularly associated with the
East – although it was also used
on occasion by the Impressionists.

TWO POPULAR ETHIOPIAN SAINTS
*Gondar (Ethiopian); 18th century; 11 x 8½ in
(28 x 21.5 cm); gouache and ink on vellum*
This illustration was painted with thick,
simple colors derived from vegetable
pigments. With the influence of Italian
and Portuguese missionaries in the 16th
and 17th centuries, Ethiopians began
to produce illustrated texts depicting
Christian saints from Africa. Two
African saints, Tokla Haymanot and
Gabra Manfas Qeddus, are seen here.

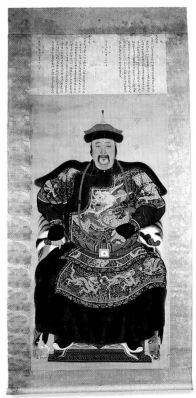

THE ADVENTURES
OF PRINCE PANJI
*Indonesian; c.1805;
illustration: 5 x 6¼ in
(12.5 x 16 cm); ink and gouache*
This illustrates a Javanese
tale that goes back to the
15th century. It chronicles
the amorous adventures
of Prince Panji, prince of
Koripan. The use of bright
gouache on highly stylized
figures is typically Eastern.
Western influences are
evident, however, in the
Dutch flags of the ships.

A BRILLIANT BLUE SEA
The way in which gouache
has been overlaid gives the
sea real depth. A brilliant
blue shines through a darker
color applied over the top.

PORTRAIT OF CAI SHIYING
*Chinese; 17th century; 76 x 39 in
(139 x 99 cm); ink, gouache, and watercolor*
Chinese portraits of this period indicated
the sitter's importance and power. In this
case, the highest quality pigments were
used: ultramarine and azurite for blue,
malachite and verdigris for green.

The art of India

THE INDIAN SUBCONTINENT has a long tradition of producing manuscript illuminations. These were executed in gouache, at first on palm leaves and then later, with the Muslim invasion in the 13th century, on paper. Early examples were inspired by the Hindu and Jain religions, and earthy colors were used. The Mogul dynasty, which governed from the 16th to 18th centuries, transformed this tradition into one of courtly art; richly colored illustrations were created through repeated layering of gouache, followed by burnishing (rubbing away at the paint surface). During the 19th century, European patronage led to the choice of more subdued subjects – frequently natural history paintings and portraits – and the use of lighter washes and less vibrant coloring.

The Bodhisattva Manjusri

c.1145; central image: 2¾ x 2¾ in (7 x 7 cm); bodycolor on palm leaf
This is taken from *The Perfection of Wisdom*. It features one of the main bodhisattvas (Buddhist gods who choose to remain on earth as spiritual guides). Painted on palm leaf, it predates the introduction of paper.

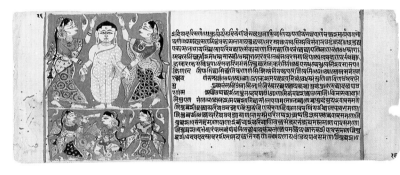

A MONK RESISTING THE ATTRACTIONS OF WOMEN
1460; 4½ x 11½ in (11.5 x 29.5 cm); ink and gouache
This manuscript describes the teachings of the founder of Jainism and sets out rules of behavior for monks. Crimson and ultramarine pigments are used lavishly.

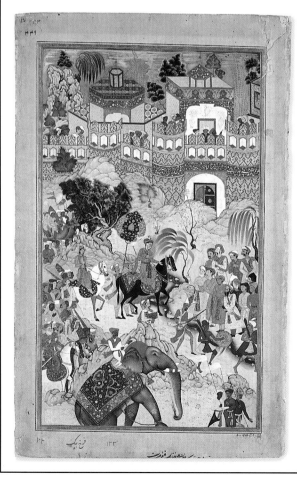

AKBAR'S TRIUMPHANT ENTRY INTO SURAT
c.1590; 12½ x 7½ in (32 x 19 cm); gouache
This illustration is from the history of the Mogul dynasty, the *Akbarnama*, which was presented to Emperor Akbar in 1590. It was painted on a thick rag-based paper that was prepared by burnishing, and then painted with layer upon layer of pigment built up to a rich coloring. It would have taken a number of artists to complete such a manuscript, since it took two artists to produce each picture. The senior one provided the outline design and details such as faces, while the junior one did all the preparation and coloring.

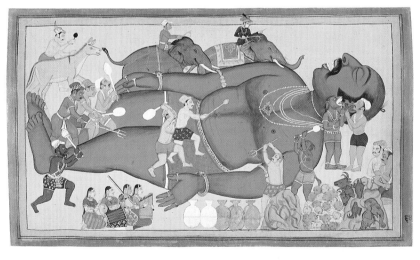

THE AWAKENING OF KUMBHAKARNA
Sahib Din; 1652; 8¼ x 13¾ in (21 x 35 cm); gouache
This illustration is from the epic *Ramayana*, a mythical tale that was based on historical fact. It shows the sleeping giant Kumbhakarna, who is awakened in order to defend his brother Ravana from the attack of Rama and his monkey allies.

Even minor characters have been lent drama and interest by the artist

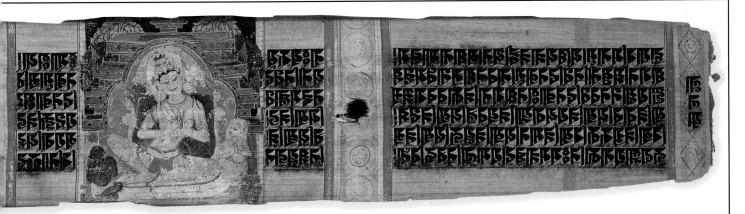

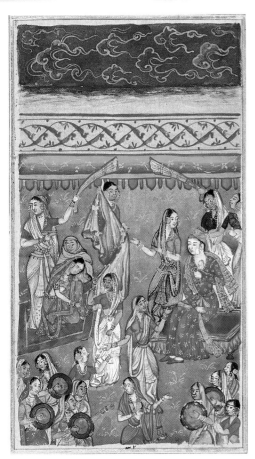

THE TOILS OF LOVE
c.1590–1600; 6½ x 3½ in (17 x 9 cm); gouache
This is in the rich Bijapuri style of painting. Bijapur was one of the three sultanates of the Deccan (central southern India), and remained independent of Mogul rule until 1686-87. The story is a romance composed in 1591 by Hasan Manjhu Khalij. Here, the hero and heroine, Shahji and Mahji, conduct an interview through a curtain.

The stylized gesture of this figure is a good illustration of the static courtly style of the period

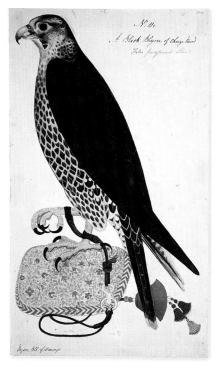

THE BOOK OF CREATION *below*
1836; 9½ x 25¼ in (24 x 64.5 cm); gouache on aloe bark
Filled with flora and fauna, this opulent manuscript represents a last great outburst of Assamese (northern Indian) art. It demonstrates how, in parts of India, the old traditional techniques and forms persisted for centuries after the introduction of the realistic styles of the Mogul artists. *The Book of Creation* is a Hindu religious text that was popular at the time.

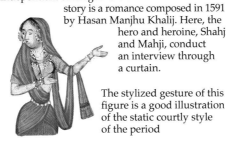

Here, Krishna (a Hindu god) is shown dancing with milkmaids in the circle of love

HAWK OR PEREGRINE
1802; 18¼ x 10¾ in (46.5 x 27.5 cm); watercolor
This was presented to a British official in India by a raja (Indian prince). It is painted in "European-style" transparent washes, rather than the traditional opaque color.

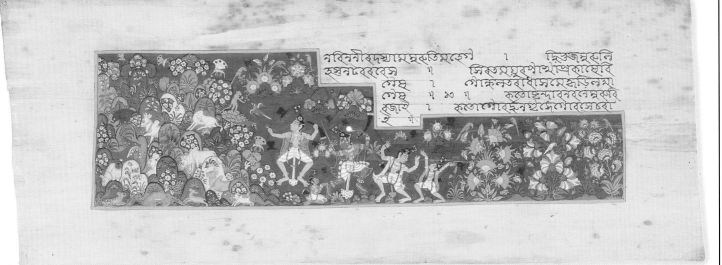

Miniature painting

Red pigment

SHADES OF RED
Red was used as the ground for many miniatures. The pigments used came from a variety of animal and vegetable sources.

Tʜᴇ ᴀʀᴛ ᴏꜰ ᴛʜᴇ ᴍɪɴɪᴀᴛᴜʀᴇ ᴘᴀɪɴᴛᴇʀ, or "limner," developed in the 16th century, and was descended from that of the illuminator of medieval manuscripts (pp. 10–13). Miniatures were small portraits, frequently requiring painstakingly detailed work by the artist. They were either carried around, worn as lockets, or sent as tokens – for example, to a prospective marriage partner. Early examples were painted in watercolor on disks of fine parchment, which were stuck onto stiff paper. Gouache was also used and, in the 18th century, parchment was replaced by ivory as the usual painting surface. Ivory is even smoother and less absorbent than parchment. This allowed artists either to apply a thin, transparent color wash and let the luminous ivory shine through – for example, on facial features – or build up thick color. In the 19th century, large miniatures, the size of small paintings, were produced on thin sheets of rolled-out ivory.

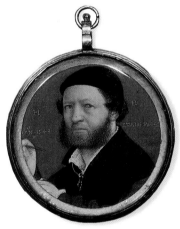

HOLBEIN'S MINIATURES
Holbein used mainly gray and red transparent watercolors, over a base color of carnation – rose pink.

MRS. PEMBERTON
Hans Holbein; c.1536; 2 in (5 cm) across; watercolor and bodycolor on vellum
Holbein, a German artist who was Henry VIII's painter, brought a new realism to miniatures.

HANS HOLBEIN
Lucas Hornebolte; c.1547; 1¾ in (4.5 cm) across; watercolor and bodycolor on vellum
It was Hornebolte who taught Holbein how to use watercolor and bodycolor on vellum.

The Family of Sir Thomas More
ROWLAND LOCKEY
c.1593; 9½ x 11½ in (24 x 29 cm); watercolor and bodycolor on vellum

The style of this unusually large miniature is like that of Hilliard (pp. 24–25). Lockey was known as "[Hilliard's] expert scholler [sic] ... skilful in limning." More – Henry VIII's lord chancellor – lost his life for refusing to approve the king's divorce from Queen Catherine.

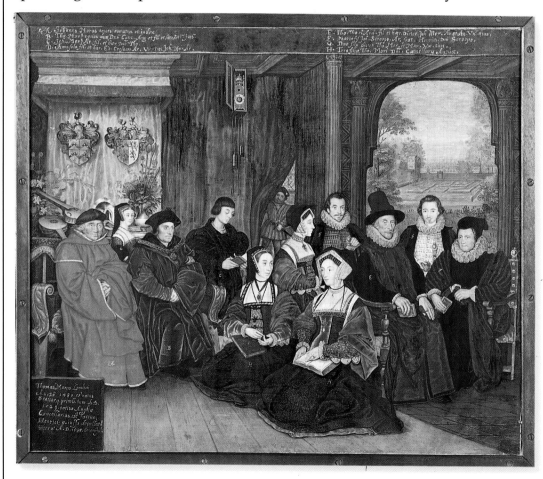

SIR THOMAS MORE
More, who was later made a saint, sits to the right of his father, Sir John More, who is shown wearing red judge's robes.

LOCKEY'S INSPIRATION
Lockey (c.1565–1616) copied this composition from a drawing of the same subject, now lost, by Holbein. He has, however, changed the background on the right.

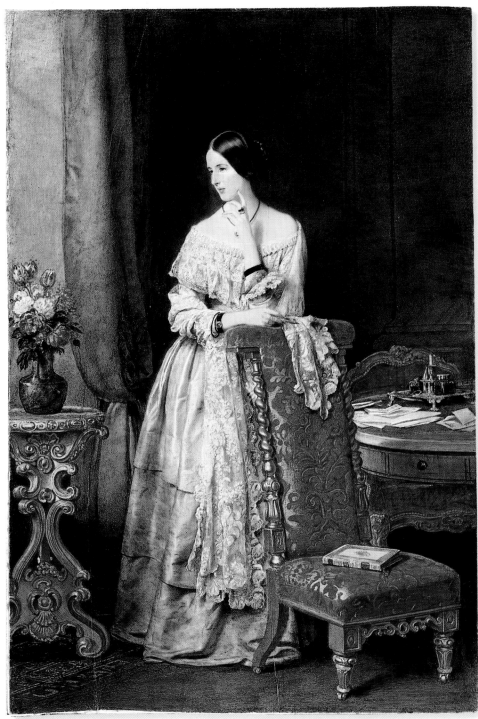

Baroness Burdett-Coutts
SIR WILLIAM CHARLES ROSS
c.1847; 16½ x 11½ in (42 x 29 cm);
watercolor and gouache on ivory

This large, elegant portrait shows how, by this date, miniaturists were trying to rival oil paintings for grandeur of effect. For example, square miniatures were replacing oval ones – in 1803, one miniaturist dismissed oval miniatures as "toys." Ross (c.1794–1860) mixed a lot of gum with his colors, giving them a rich sheen, but used little gouache, saving it for the brightest areas of his paintings.

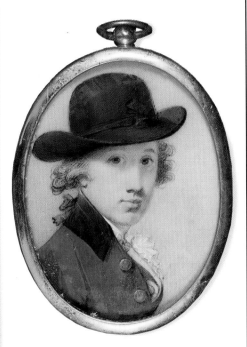

SIR THOMAS STEPNEY
George Engleheart; c.1775–80; 2 x 1½ in
(5 x 4 cm); watercolor and gouache on ivory
Engleheart allows the polished surface of the ivory to shine through, and mainly transparent watercolor is used. He has painted vertical strokes of blue-gray or pink onto a pale-colored wash, adding gouache for the clothing and background.

1811 miniature of William Reeves, nephew of the founder of Reeves

A MINIATURIST AT WORK
This pen and pencil drawing (c.1815–20) by Mary Grimaldi shows her father-in-law, William Grimaldi – miniaturist to George III and George IV. The angled stand on the desk enabled the miniature to be raised up so that the artist could work without excessive strain.

PORTABLE MINIATURIST'S EASEL
This type of easel was used in the 18th and 19th centuries. The drawer stored equipment such as brushes (squirrel or sable), a water bowl, ivory palettes, and pots of paint (or commercially made cakes of paint, after about 1800).

Portrait of an era

The work of Nicholas Hilliard (1547–1619), the first great British miniaturist (pp. 22–23), provides a vivid picture of Elizabethan and Jacobean life. Elizabeth I's miniaturist, he applied flesh tints with delicate washes, drawing in facial features with a pen, as he explained: "little light touches with color very thin, and like hatches, as we call it, with the pen." Hilliard considered Holbein (p. 22) to be "the greatest master" and was also influenced by "the most excellent Albrecht Dürer" (pp. 16–17). His early portraits were round, but he soon adopted the oval format, which gave more scope for depicting the elaborate costume of the day. By the 1580s, he was producing large, rectangular portraits with intricate backgrounds. In his treatise on miniature painting, Hilliard claimed that the art "tendeth not to common men's use," and that artists should "take heed of the dandruff of the head shedding from the hair."

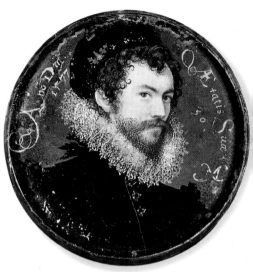

SELF-PORTRAIT
Nicholas Hilliard; 1577; 1½ in (4 cm) across; watercolor and bodycolor on vellum
Hilliard depicts himself aged 30, the year after he had married. This miniature forms a companion to one of the artist's father.

Front cover

Ruby — *Diamond*

THE HENEAGE ("ARMADA") JEWEL
Nicholas Hilliard; whole pendant: c.1588; miniature inside: 1580; 2¾ x 2 in (7 x 5 cm); watercolor and bodycolor on vellum
This pendant opens to reveal a portrait of Elizabeth, who gave it to Sir Thomas Heneage on the defeat of the Spanish Armada. The jeweled frame is enamel and gold. Elizabeth disliked the use of shadow – like many Hilliard portraits, this one is rather two-dimensional.

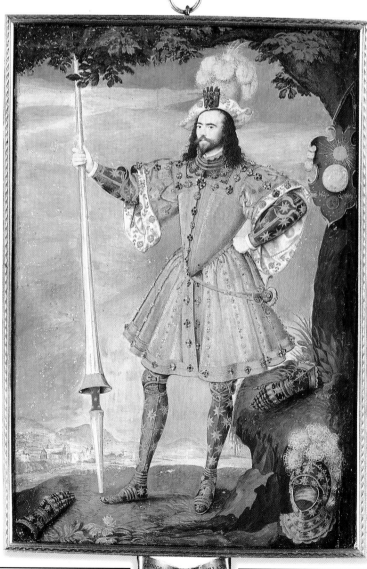

GEORGE CLIFFORD, THIRD EARL OF CUMBERLAND, AS THE KNIGHT OF PENDRAGON CASTLE *left*
Nicholas Hilliard; c.1590; 10 x 7 in (25.5 x 18 cm); watercolor and bodycolor on vellum
Despite the freely painted background, this is a highly finished work. Apparently monumental in scale, the magnificent, full-length portrait is, in fact, quite small (although it is Hilliard's largest surviving miniature). Clifford, a buccaneer and courtier, enjoyed Elizabeth I's favor – he wears her diamond-set glove in his hat.

SIR WALTER RALEIGH
Nicholas Hilliard; c.1585; 2 x 1¾ in (5 x 4.5 cm); watercolor and bodycolor on vellum
Here, the adventurer is depicted very much as a courtier. Hilliard used Dürer's rule "that the forehead is of the length of the nose, and the nose as long as from the nose to the chin."

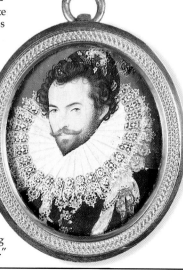

Hilliard used a mussel shell,
such as this, as his palette.
He bought his pigments
at an apothecary's shop
(the equivalent of the
modern drugstore)
and ground them up.
In the shell, he would
have mixed the pigment
with a binding agent, such
as gum arabic. If the paint
was still too dry, some "sugar
candy" was added, and if the
color did not take well, because
a "sweaty hand or fatty finger
hath touched your parchment,"
then a little earwax was added!

Mussel
shell

Young Man Among Roses

NICHOLAS HILLIARD

c.1587; 5¼ x 2¾ in (13.5 x 7.5 cm);
watercolor and bodycolor on vellum

This famous image probably shows
Robert Devereux, second earl of
Essex. He is clothed in Elizabeth
I's colors, black and white, and
surrounded by eglantine (a wild
rose), one of her favorite flowers.
The inscription at the top translates
as: "My praised faith causes my
sufferings." Essex may have been
trying to appease the Queen, who
was reportedly displeased at his
marriage to the widow of another
favorite, Sir Philip Sidney. The
colors used reflect Hilliard's belief
that "besides black and white, there
are but five other principal colors ...
murrey [deep red or purple], red,
blue, green, and yellow."

FINE DETAIL
The realistically
painted plants –
compare the detail
above with the photograph on the
right – are shown with the same accuracy
as the plant decoration of medieval texts.
Their meaning is linked to the symbolism
associated with roses: joy and pain, love
and purity. The pricks of the thorns could
be compared to the wounds of love.

The wild
rose, eglantine
(or sweetbrier)

Exploring new worlds

WATERCOLORS PAINTED by early travelers were vital to the documentation of new worlds. The age of exploration began with the Renaissance, with men like Christopher Columbus. Soon there was a demand for accurate reporting of what had been seen. In the late 16th century, explorers began to use drawings to illustrate verbal and written reports, and watercolor was frequently used to add color. By the 18th century, as commercial links were forged between Europe and the rest of the world, embassies and scientific expeditions often employed specialist watercolorists such as William Alexander. By this time, watercolor was gaining in stature, and many sketches were worked up into finished paintings for public exhibition.

MAPPING THE WORLD
This is a map of the empires and the countries of the world in 1846. It shows how, by the mid-19th century, European nations had claimed most of the previously "undiscovered" parts of the world as their own. England, for instance, is colored pink, along with its colonies, such as Canada and Australia.

Livingstone's compass

OPENING UP AFRICA
This compass belonged to Scottish missionary Dr. David Livingstone, who explored vast areas of Africa between the 1840s and 1870s.

Eskimo Woman and Baby
JOHN WHITE *c.1585–90;*
8¾ x 6½ in (22 x 16.5 cm); pencil, watercolor, and bodycolor
White (1575–93), the earliest European watercolorist to paint American scenes, sailed with the fleet that established the first English colony in North America. His style was simple – limited colors, with white bodycolor for high-lights – as his principal aim was to record what he saw.

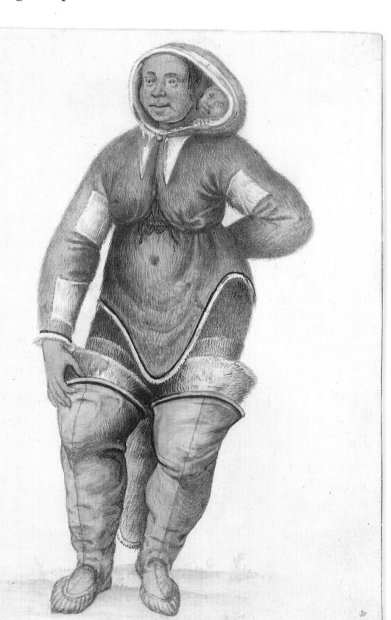

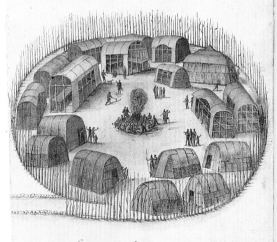

The towne of Pomeiock and true forme of their houses, couered and enclosed, some wth matts, and some wth barcks of trees. All compassed abowt wth Smale poles stuck thick together in sted of a wall.

THE VILLAGE OF POMEIOOC
John White; c.1585–93; 8¾ x 8½ in (22 x 21.5 cm); pencil, watercolor, and white and gold bodycolor
This study of a fortified Indian village has been outlined first with a lead pencil. Watercolor was then applied directly onto untreated paper. The preparatory sketch was later touched up with black watercolor.

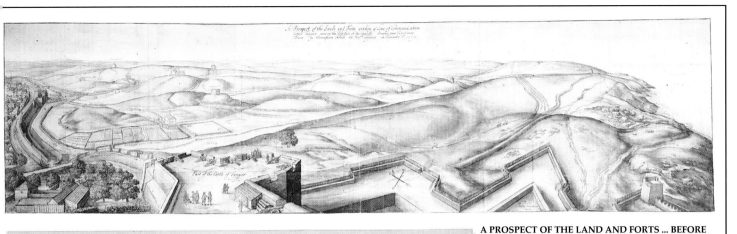

A PROSPECT OF THE LAND AND FORTS ... BEFORE TANGIER DRAWNE FROM PETERBOROW TOWER
Wenceslaus Hollar; 1669; 11 x 40¼ in (28 x 102 cm);
pen and ink with watercolor on nine joined pieces of paper
Hollar accompanied an expedition to Tangier, in North Africa, in 1669. "Designer of prospects" to Charles II, he was assigned to draw and map the area, recently acquired by the English king. Czech-born Hollar was primarily a printmaker – evident from his simple technique. This watercolor uses a deliberately limited range of blues and greens to produce a functional record of the Tangier walls.

CHINESE BARGES OF LORD MACARTNEY'S EMBASSY, PREPARING TO PASS UNDER A BRIDGE
William Alexander; 1796; 12 x 18 in (30.5 x 46 cm); watercolor
Alexander accompanied a British trip to China in 1793–94. Once back in England, he painted watercolors based on his on-the-spot sketches; the absence of pencil drawing suggests that this is one of these later works, rather than a sketch.

COLUMNS OF THE TEMPLE ZEUS, AT ATHENS
Dominique Papety; 1846; 16¼ x 11½ in (41.5 x 29 cm); pencil and watercolor
In 1847, the French artist Papety published an account of his travels in Greece. His work was influential in France, turning the attention of artists such as Ingres (p. 54) to ancient Greek, rather than Roman, art. Here, he uses watercolor over a black lead sketch.

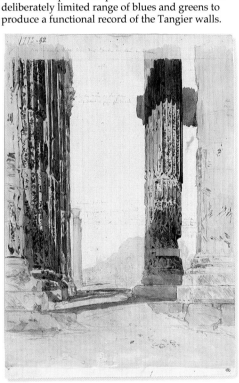

COLLECTING SAMPLES
This leather satchel (left) was used by the English explorer and botanist Sir Joseph Hooker throughout his travels. He placed any interesting plant species that he came across into this bag. Having collected such samples, it was vital that they be recorded by artists, who became key members of the great 19th-century expeditions. Hooker traveled widely during the mid- and late 19th century. He accompanied Sir James Ross's 1839 expedition to the Arctic and explored many parts of Asia.

19th-century botanist's satchel

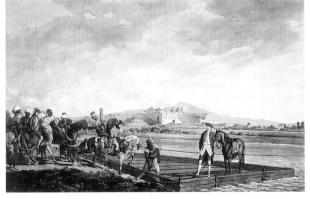

THE THEATER AT MILETUS
William Pars; c.1765; 11½ x 18½ in (29.5 x 47 cm); pen, watercolor, gum arabic
Pars joined an expedition exploring the antiquities of Asia Minor in 1764. His use of pen is highly effective – here, it seems to have been dipped in gray wash; ink is reserved for dark areas and the foreground. With its pale washes, the temple takes second place to the foreground group, shown in intense color and strong ink work.

The portable art

For 18th- and 19th-century travelers and tourists, sketching in watercolor was the perfect way to record their tours. It was particularly suitable because the light, minimal materials were easy to carry. Spurred on by natural curiosity, fashion, and newly published guidebooks, people journeyed surprising distances. Italy, with its classical sites, was one of the most popular destinations. A visit to Rome became, at this time, a compulsory part of the "Grand Tour" – the long European journey that it was fashionable for young aristocrats to make. More distant countries, such as Egypt, came into reach by the mid-19th century, when the equivalent of a "package tour" could be arranged.

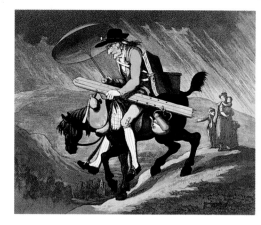

AN ARTIST TRAVELING IN WALES
Thomas Rowlandson; 1799;
10½ x 12¾ in (26.5 x 32.5 cm); aquatint print
This tongue-in-cheek print makes fun of the traveling artist, prepared to cross the Welsh countryside even in atrocious weather. Expense was also an obstacle to painters making sketching trips. On a tour of north Wales in 1835, Samuel Palmer (p. 42) wrote: "Had I conceived how much it would cost, I would as soon have started for the United States as Wales."

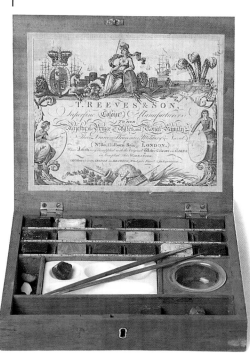

PORTABLE PAINT BOX
T. Reeves & Son, the makers of artists' materials, produced this wooden watercolor box from 1766 to 1783. The inclusion of a tray for mixing paints and a built-in water pot meant that it was not only portable but also suitable for painting outdoors on location.

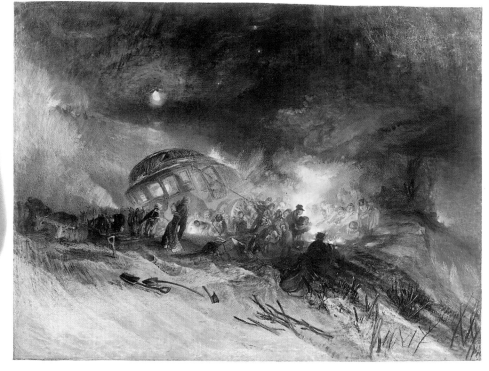

RUINS OF PAESTUM, NEAR SALERNO: THE THREE TEMPLES
John Robert Cozens; 1782;
10 x 14½ in (26 x 36 cm); watercolor
Cozens (1752–97) was the artist who opened British eyes to the beauty of the Italian landscape. He made several trips to Italy, employed as a traveling artist to record the sights. In 1782–83, he accompanied his rich patron William Hamilton there, filling seven sketchbooks with drawings. These he used later as the basis for the fully worked-up Italian watercolors that he produced for British clients. This view is of the ancient Greek temples at Paestum, in southern Italy.

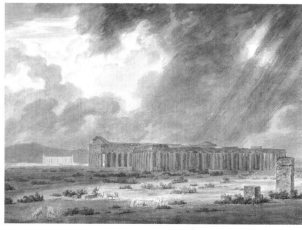

MESSIEURS LES VOYAGEURS IN A SNOW DRIFT UPON MOUNT TARRAR
J.M.W. Turner; 1829; 21½ x 29½ in
(54.5 x 75 cm); watercolor and bodycolor
For the subjects of his paintings, Turner (1775–1851) was dependent on the sketching tours that he undertook once or twice a year. In Italy, he was particularly inspired by the strength of the light that he encountered there, which was so different from that of his native England. This watercolor records Turner's hazardous journey home from his second trip to Italy, in 1828–29. All travelers had to pass over the Alps by "diligence" (stagecoach). He recalled, "The snow began to fall at Foligno, tho' more of ice than snow, so that the coach from its weight slide [sic] about in all directions ... till at Sarre-valli the diligence slid into a ditch, and required six oxen, sent three miles back for, to drag it out ..."

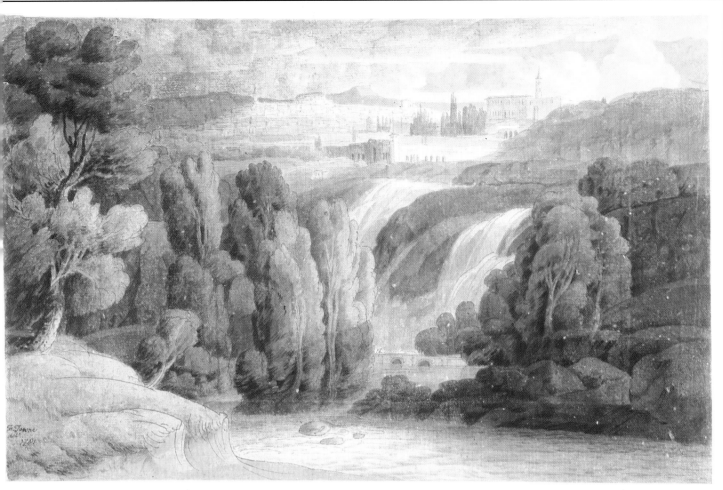

Tivoli From Below the Waterfalls

FRANCIS TOWNE *1781; 10 x 15½ in (20.5 x 39.5 cm); pen and watercolor*
Towne (1739/40–1816) captured this view of Tivoli, near Rome, during a stay in Italy from 1780 to 1781. Kept in albums, his brilliantly colored drawings were outlined in pen.

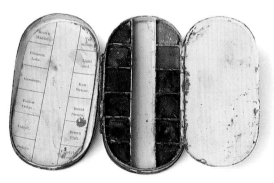

POCKET PAINT
This oval pocket box (1900) was manufactured by Winsor and Newton, one of the main paint suppliers in the 19th century. It contains a set of 12 watercolors and was a popular item with artists who wanted to make rough watercolor sketches while out "on location."

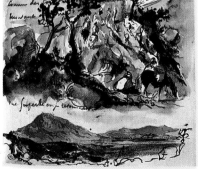

LANDSCAPE AT EIN DALIAH BETWEEN MEKNES AND TANGIERS
Eugène Delacroix; 1832; 3¾ x 6¼ in (9.5 x 16 cm); pen and watercolor
Delacroix (1798–1863) was the leader of the 19th-century French romantic movement in painting. This page is taken from his North African travel diary of 1832, where notes and rapidly made watercolor sketches are mixed together.

ILLUSTRATED CATALOG
Winsor and Newton produced illustrated annual catalogs, as comprehensive guides to their artists' supplies. The pages here feature an oval pocket box, shown above, and a small locket box on a ribbon (1850) – worn around an artist's neck.

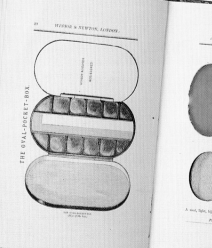
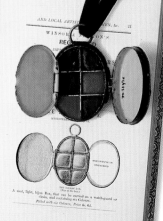

Satirical images

SATIRE – THE CRITICISM of vice or folly through ridicule – is one of the most fundamental human impulses to be explored by artists. Satirical drawings can be found in ancient and medieval art, where the features and actions of humans, animals, and deities are exaggerated for comic effect. Watercolor has traditionally been favored by satirists for individual works of art and for the coloring-in of sizable print runs of black-and-white prints that bring a social or political message to a larger audience. The great satirical watercolors were produced from the late 18th century onward, beginning with the social comedies – often cruel – of Thomas Rowlandson (1756–1827). Political satire, which was even harder-hitting, developed at this time and was typified in France by the work of Honoré Daumier (1810–79).

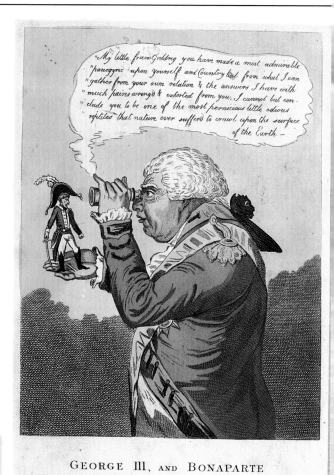

GEORGE III, AND BONAPARTE
AS
The King of Brobdignag and Gulliver.

GEORGE III AND BONAPARTE (NAPOLEON)
James Gillray; c.1803; 6 x 4 in (15 x 9.5 cm); etching and watercolor
Gillray (1757–1815) was the major British caricaturist of the late 18th and early 19th centuries. His prints focused on the British monarchy, politicians, and foreigners. In particular, he satirized the perpetrators of the Reign of Terror in France after the Revolution in 1789. His etchings were sold from a shop in London; uncolored they cost a shilling each; colored ones were half a crown. The coloring, in watercolor washes, was carried out by a team of women assistants working from a master copy provided by the artist.

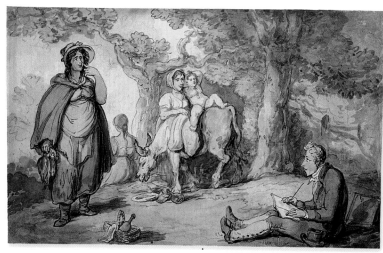

SKETCHING A COUNTRY WOMAN
Thomas Rowlandson; 5½ x 9 in (14 x 22.5 cm); pen and watercolor
Rowlandson was an extremely prolific artist with a remarkably fluid drawing style. He drew thousands of humorous watercolors. In this painting, he lampoons the 18th-century fashion for artists to go out into the countryside to sketch rural life. The main woman to the left is stupid and boorish. She does not correspond to the idea, commonly held at the time, of country folk being pure and unspoiled by the corruption of city life. Even so, the artist, obviously a man of little discrimination, dutifully draws her. The design was sketched in pen and then rapidly filled in with watercolor washes.

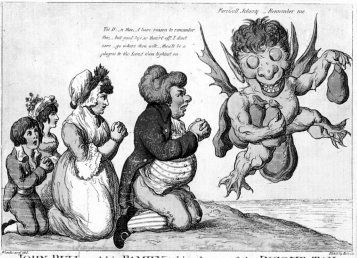

JOHN BULL and his FAMILY taking leave of the INCOME TAX

JOHN BULL AND HIS FAMILY TAKING LEAVE OF THE INCOME TAX
P. Roberts; 1802; 9¼ x 13 in (23.5 x 33.5 cm); etching with watercolor
This hand-colored etching is typical of the popular caricatures of Georgian England, in which people were used to illustrate the main issues of the day. John Bull, shown with his family, represents the typical Englishman. The demon symbolizes the hated income tax, which had first been introduced in 1799 to help pay for the war against the French. Here, it is the withdrawal of the tax that is satirized, following the peace with France in 1802. The demon says, "Farewell Johnny – Remember me." John Bull replies, "... thou'lt be a plague to the Land thou lightest on."

TWO DRINKERS *right*

*Honoré Daumier; c.1857–60; 7¼ x 10 in
(18.5 x 25.5 cm); pen, watercolor, and gouache*

A prolific draftsman, Daumier produced many satirical drawings that were reproduced in French newspapers as lithographic prints. His drawings poked fun at French society, and Daumier was even imprisoned for his biting satires. This drawing has a tragicomic tone. The drinkers, clearly well-seasoned alcoholics, wear the overly earnest expressions of semi-drunks in discussion. His deliberately imprecise use of line only adds to the general air of confusion. Daumier had stopped producing newspaper illustrations by this time, so the sale of drawings such as this provided him with an important source of income.

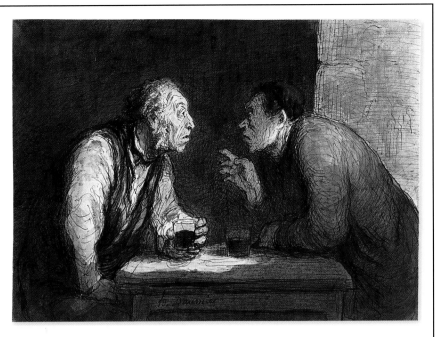

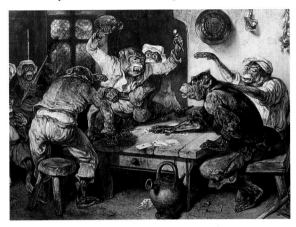

DISCORD

*Alexandre Gabriel Decamps; 1833;
16 x 24½ in (41 x 62 cm); watercolor*

This was exhibited at the 1833 Paris Salon with a companion drawing, *Perfect Harmony*, which showed monkeys playing music. The titles were a play on words referring to musical harmony, and a highly sarcastic comment on human behavior. Since classical times, monkeys had been a symbol of evil. In these pictures, their behavior mimics that of humans – the message being that man is always capable of evil. The number 45 is scratched onto the surface of the painting, a reference to a secret club called *La Société des 45*, of which Decamps (1803–60) was a member.

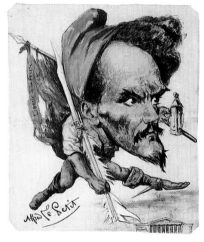

CARICATURE PORTRAIT OF THE POLITICAL JOURNALIST HENRI ROCHEFORT (1831–1913)

*Alfred Le Petit; 1869; 12½ x 10¾ in
(31.5 x 28 cm); black chalk and watercolor*

This drawing illustrates how the caricature began to be used as a tool for political satire. Rochefort's features are deliberately exaggerated and his quill pen is portrayed as a "sword." Le Petit (1841–1909) fought for the rights of a free press in Paris and was often in trouble with the authorities.

SIR CECIL HARCOURT SMITH RECEIVES A DEPUTATION

*Sir Max Beerbohm; 1924; 16 x 12½ in
(40.5 x 31.5 cm); pencil and watercolor*

This satire pokes fun at the meeting of the lean director of the Victoria and Albert Museum in London and a rotund group from the north of England, eager to acquire "culture." In his caricatures, Beerbohm (1872–1956) wished to capture "the peculiarities of the human being ... in the most beautiful manner." His pale washes here are evocative of some of Rowlandson's work.

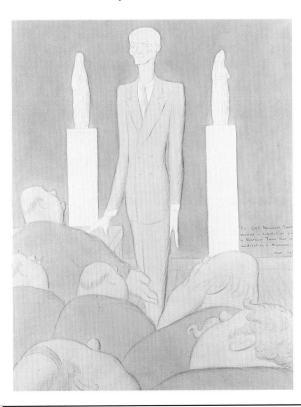

MAGGIE THATCHER

*David Lewis; 1992; 11½ x 8 in
(29.5 x 21 cm); pen, ink, and watercolor*

Here, the artist emphasizes Baroness Thatcher's "regal" perception of herself – hence the royal wave and the slight lean forward, as though to an adoring crowd. Her facial features are exaggerated into a rather threatening fixed grin with the lips drawn back over the gums, almost wolflike. Lewis, a professional caricaturist, uses markers for his most rapid sketches, and pen and ink with watercolor for his more finished works.

The British tradition

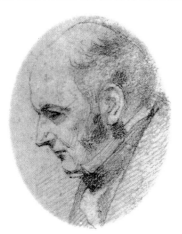

JOHN CONSTABLE
This is a detail of a drawing by the Irish artist Daniel Maclise. It shows Constable in 1831, at the age of 55. The drawing was probably made on the occasion of a visit by Constable – a senior figure in the art world – to the Royal Academy Life Schools, where Maclise was a pupil.

Bᴇᴛᴡᴇᴇɴ ᴀʙᴏᴜᴛ 1750 and 1850, watercolor was very much associated with British artists. The portability of watercolor equipment meant that it could easily be carried around by artists and travelers increasingly curious about the scenery of Great Britain (pp. 28–29). It became the fashion for young men and women to be proficient in "polite" activities such as dancing, music, and painting in watercolor (pp. 40–41). These amateurs required instruction from professional drawing masters who, in turn, harbored serious ambitions for their own watercolors. By the early 19th century, there were many talented watercolorists in Britain. Masters of the medium, such as Thomas Girtin (1775–1802) and David Cox (1783–1859), rank among the finest British painters – as does J.M.W. Turner (1775–1851, pp. 36–37). While the great English landscape artist John Constable (1776–1837) worked mainly in oils, his powerful watercolors mark a significant contribution to the British tradition.

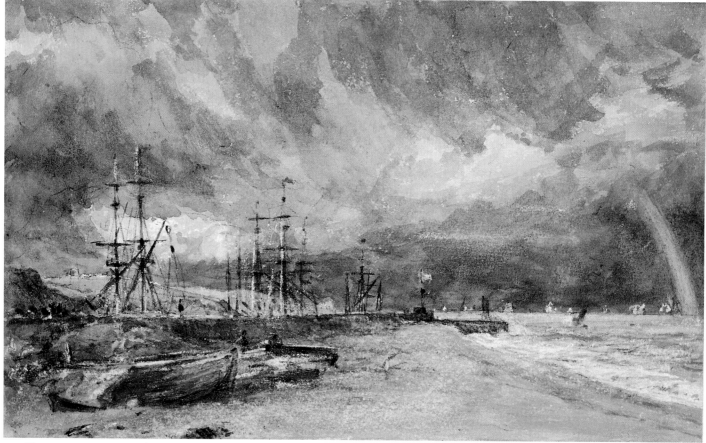

Folkestone Harbor with a Rainbow

JOHN CONSTABLE *1833; 5 x 8¼ in (12.5 x 21 cm); watercolor*
This was painted when Constable visited Folkestone to be with his son John Charles – a pupil at a boarding school in the town – who had injured himself. Constable's ability to capture dramatic weather conditions is wonderfully demonstrated here. He found watercolor highly suitable for the rapid portrayal of nature, using it extensively to make preparatory sketches, in particular cloud studies, for his oils.

LOOKING IN DETAIL
The viewer's eye is focused with this central flag, one of few splashes of bold color in the painting. In the surrounding sky, washes are allowed to run into one another, and parts of the paper are left unpainted, to indicate sunlight bursting through.

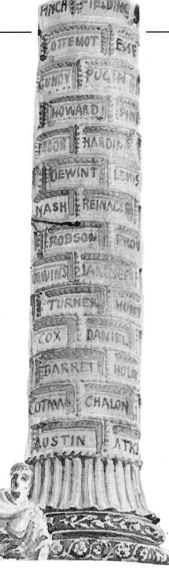

KIRKSTALL ABBEY, YORKSHIRE – EVENING

Thomas Girtin; c.1800–01; 12½ x 20½ in (31.5 x 52 cm); watercolor
Turner, Girtin's contemporary, recognized his short-lived rival's genius: "Had Tom lived, I would have starved." Girtin had a huge influence on the watercolor landscape. His strong, varied colors moved away from the more monochromatic (one-color) approach of many artists at the time, and he pioneered the use of strong cartridge paper. This sort of finished work would have been based on pencil sketches made on the spot and then worked up in the studio. As grandly constructed as any landscape in oils, the semi-transparent washes and delicate effects of watercolor are more suitable for conveying the atmosphere of this scene.

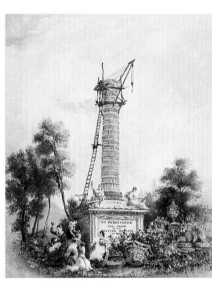

A MONUMENT TO PERPETUATE THE FAME OF BRITISH ARTISTS 1823
This 1830 watercolor (right, detail above), by James Prinsep, was the frontispiece to an album of works by British watercolorists. John Glover has the most prominent place on the column. Turner is only halfway up!

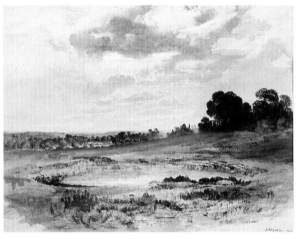

LANDSCAPE

John Martin; 1839; 9¼ x 12¾ in (23.5 x 32.5 cm); watercolor
Best known for large, melodramatic paintings of biblical subjects, Martin (1789–1854) was also a highly accomplished watercolorist. Scenes such as this are typical of him, and show a use of fairly rich, dense watercolor. As the century progressed, artists tended to prefer richer colors, similar to oils in effect.

THE NIGHT TRAIN

David Cox; 1840s; 11¼ x 15 in (28.5 x 38 cm); watercolor
Cox produced several paintings of this subject. The train shown is probably the night express from Liverpool to Birmingham, where the painter lived. The telling juxtaposition of the horses in the foreground with the train rushing along in the distance is almost certainly intended as a comment on the Industrial Revolution. Cox has used the scratching out of highlights and broken brushwork to give a vivid sense of drama to the picture.

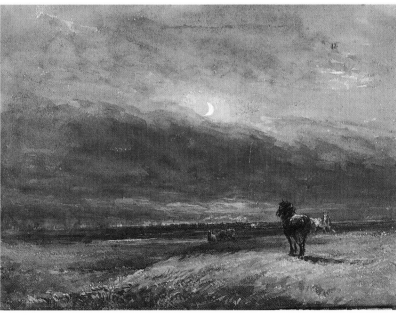

Cotman – a sense of place

JOHN SELL COTMAN (1782–1842) was the most exceptional of the Norwich School of artists, which flourished at the beginning of the 19th century in eastern England. The flat areas of watercolor that he used in his early paintings gave his designs a semi-abstract appearance. He may have owned several albums of Chinese drawings, and it is possible that he was influenced by the more abstract aspects of Oriental art. His best works are those that he painted during his early 20s; they include the landscapes of Yorkshire, which he produced while he was employed as a drawing master there. In 1831, he started mixing watercolor with rice paste to produce a rougher, richer paint surface. His work, now considered innovative, was overlooked for much of the 19th century.

JOHN SELL COTMAN
This was etched by Mrs. Dawson Turner of Yarmouth, Norfolk, in 1818, after a drawing by J.P. Davis. Her husband helped to support Cotman financially, commissioning him to illustrate books on churches in Norfolk and the scenery in Normandy, France.

Greta Bridge
JOHN SELL COTMAN
*c.1807; 8¾ x 12¾ in (22.5 x 33 cm);
pencil and watercolor*
This famous British watercolor has a balanced composition and a highly serene atmosphere. It was based on a sketch made in Yorkshire in 1805.

GRETA BRIDGE
*John Sell Cotman; 1810; 11¾ x 19¾ in
(30 x 50 cm); pencil and watercolor*
A later version of the famous picture of the same title, both paintings probably shared the same preparatory drawing. The colors here are stronger and not as subtle as in the original.

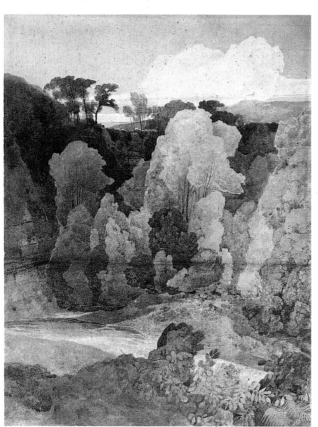

DEVIL'S ELBOW, ROKEBY PARK
John Sell Cotman; c.1806–07; 17¾ x 13¾ in (45 x 35 cm); pencil and watercolor
Painted in Rokeby Park, Yorkshire, this scene is close to the location of *Greta Bridge*. The trees are shown here as separate areas of almost flat color, defined by their outlined shapes. Cotman was extraordinarily bold in his use of a high horizon, which allowed him to concentrate on the steep riverbank.

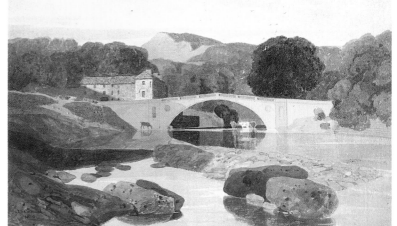

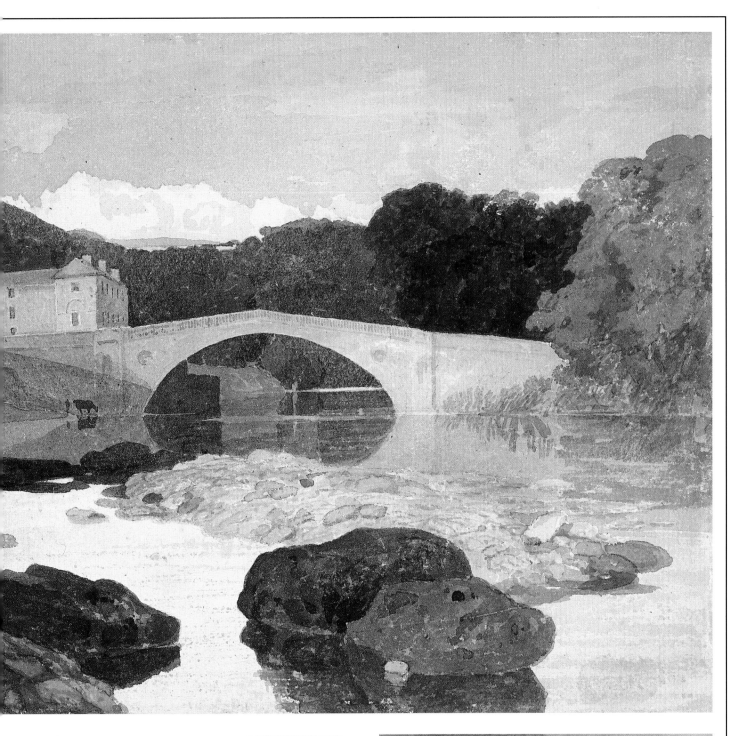

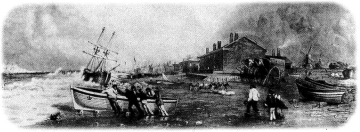

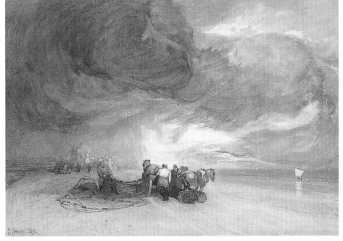

YARMOUTH BEACH DURING A STORM

Cotman lived in the English coastal town of Yarmouth from 1812 to 1823. This 1821 etching reflects the general artistic interest that developed during the early 1800s in the sea and its wilder weather conditions.

STORM ON YARMOUTH BEACH

John Sell Cotman; 1831; 14½ x 21 in (37 x 54 cm); pen, ink, and watercolor

By the 1830s, Cotman was using stronger, less subtle colors than those of *Greta Bridge* (1807). He painted the dramatic sky with a dry brush, and scraped out highlights.

Turner and landscape

JOSEPH MALLORD WILLIAM TURNER (1775–1851) was described by the 19th-century art critic Ruskin as "the most perfect landscape artist who has ever lived." In his thousands of watercolors, Turner showed both technical brilliance and a deep understanding of the medium. He worked rapidly, employing a wide range of techniques. For example, he sometimes manipulated color with his fingers, rather than a brush, and grew his "eagle claw of a thumbnail" long for scratching out highlights. Blotting paper and bread crumbs were used for removing color from certain areas, and partly finished watercolors were immersed in water so that colors would blend into each other. Turner even made use of his saliva – to keep colors moist as he worked with them on the paper.

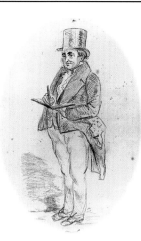

J.M.W. TURNER
Charles Martin's pencil portrait of Turner was drawn in 1844. Turner began as an architectural draftsman and print colorer, and became one of the great artists of his age. He was buried, after "lying in state" at his studio, in St. Paul's Cathedral, London.

CRITICAL RESPONSE
This cartoon of Turner (c.1846) refers to widespread criticism of his "free" painting technique. Critics were confused by the artist's bold colors and the stress that he laid on color rather than form.

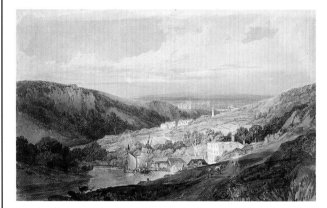

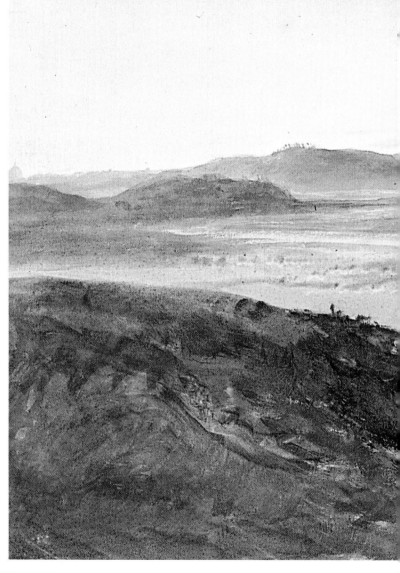

IMAGINARY LANDSCAPE WITH WINDSOR CASTLE
J.M.W. Turner; c.1800; 18 x 29 in (46 x 74 cm);
pencil, watercolor, and bodycolor
This was based on Turner's drawings of Windsor Castle and on others made on his Welsh tours. It is typical of his earlier watercolor work. The relatively narrow color range and emphasis on tonal balance was characteristic of topographical artists of the time.

View of the Campagna, Italy
J.M.W. TURNER *1819; 10 x 16 in*
(26 x 40.5 cm); pencil and watercolor
Turner's view of the countryside around Rome shows how he used "color beginnings" to develop a watercolor. He began to work out the design with almost abstract areas of color, rather than detailed pencil drawing. Edges were then sharpened to suggest the outlines of hills, and washes that were still wet were brushed into one another to indicate mist and haze.

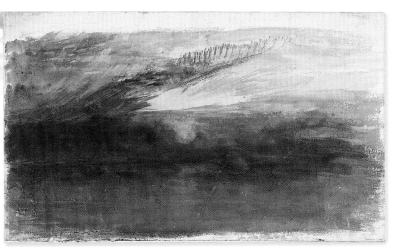

THE SUN SETTING AMONGST DARK CLOUDS
J.M.W. Turner; c.1825; 11 x 18 in (27.5 x 47 cm); watercolor
This dramatic work shows Turner's range as a water-colorist. The power of nature fascinated him, and this work, with its total lack of human subject matter, is almost abstract in effect. Black, a color avoided by most watercolorists, is used here to telling effect.

These cakes of paint give an idea of the "sunset colors" of Turner's palette

The pouch opens like a book, having been made from the binding of an almanac

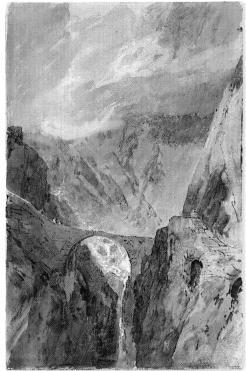

Watercolor cakes are stuck to the inside of the case

WATERCOLOR CARRYING CASE
The leather watercolor case shown here, which belonged to Turner, was intended to be convenient to use and easily portable, and he no doubt took it along on his many sketching trips. Turner actually made the watercolor case himself, cleverly using the leather jacket of an almanac.

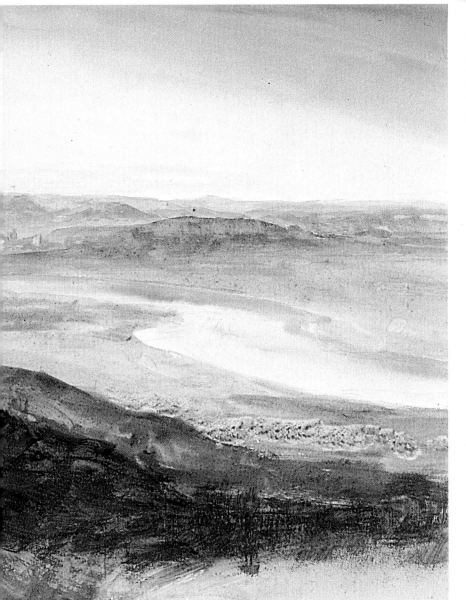

DEVIL'S BRIDGE, PASS OF ST. GOTHARD
*J.M.W. Turner; 1802; 18½ x 13¾ in
(47 x 35 cm); pencil, watercolor, and bodycolor*
Turner has used scraping out to portray the icy Alpine stream that cascades down the mountainside under the bridge. The bleak, rocky landscape of the upper Alps is depicted with the minimum of color.

Exhibition works

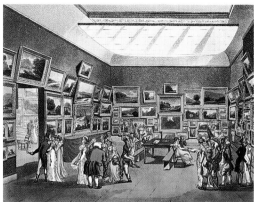

SEVERAL WATERCOLOR exhibiting societies were founded in Britain in the early 19th century, due to a growing demand from watercolorists for suitable exhibition venues. Watercolors were now seen as legitimate paintings rather than mere tinted drawings. In emulation of oil paintings, they became larger, were displayed in gold frames, and used brighter, richer colors – opaque bodycolor was often mixed with transparent watercolor. Glazes of gum arabic were painted over some works to give colors body and depth, much as varnish is applied to oil paintings.

WATERCOLORS ON DISPLAY
The Society of Painters in Watercolours was founded in Britain in 1804. This print (reproduced from a watercolor) appeared in a periodical of the time. It shows the society's 1808 exhibition at 16 Old Bond Street, London. Many of the works were of considerable size, and all were framed. The Society's intention was to rival the annual exhibition of oil paintings at the Royal Academy.

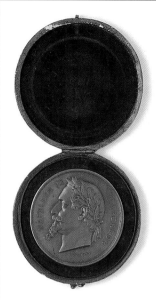

ORDERS OF MERIT
These medals were awarded to the art supplier Reeves & Son for its paints. Founded in 1766 in London, it made prize-winning cakes of watercolor that advanced the art (previously, artists had to mix their own paints). The medal above was won at an exhibition in Paris, in 1867; the one on the right, at an 1812 London exhibition.

The Museum Staircase
JEAN-BAPTISTE ISABEY *1817;*
33¾ x 26 in (86 x 66 cm); watercolor

This large painting by Isabey (1767–1855), of a staircase in the Louvre, was exhibited at the 1817 Paris Salon. It marked an important stage in the exhibition of watercolors in France – critics marveled at its detail and sparkling color. Watercolor was widely practiced in France and gained extra impetus in the 1820s from the landscapes of English artists such as John Constable.

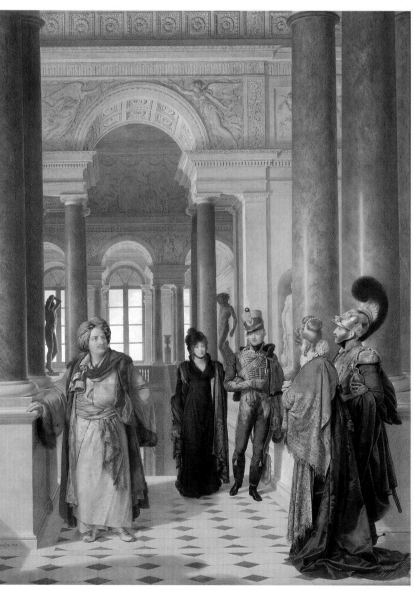

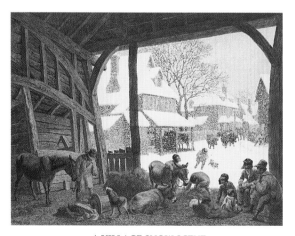

A VILLAGE SNOW SCENE
Robert Hills; 1819; 12¾ x 16¾ in
(32.5 x 42.5 cm); watercolor and bodycolor
Here, snow is depicted by leaving parts of the paper unpainted and "scraping out" the snowflakes (with a sharp point). A founding member of Britain's Society of Painters in Watercolours, Hills often imitated old masters. This scene echoes Rubens's *Barn in Winter* and the work of Brueghel.

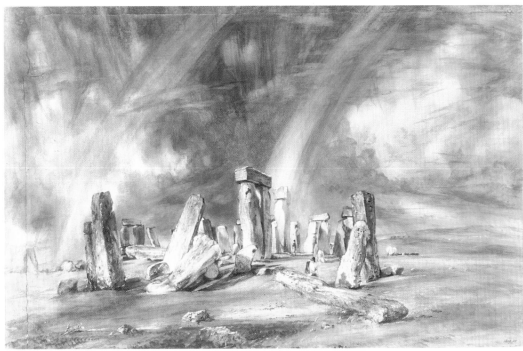

STONEHENGE
*John Constable; 1836; 15¼ x 23¼ in
(38.5 x 59 cm); watercolor*
Although Constable (1776–1837)
was primarily a painter in oils, he
painted several major watercolors
toward the end of his life. This
dramatic work was exhibited at the
Royal Academy in 1836. For the sky,
in particular the rainbows, color
has been partially wiped off. The
rain effect at the top of the painting
has been created by scratching color
on with a stiff brush.

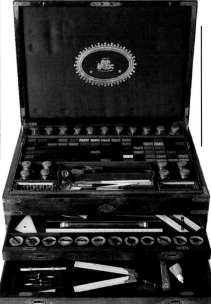

**THE THAMES AT
ISLEWORTH** *right*
*John Glover; c.1805–10;
27 x 40 in (68.5 x 102 cm);
watercolor*
This unfinished
drawing shows how
the "skeleton" of such
a watercolor was laid
out. Glover began with
tonal washes, often in
indigo or clay red ink,
before adding color.
He would later
dampen the paper
in order to achieve
a softening effect.

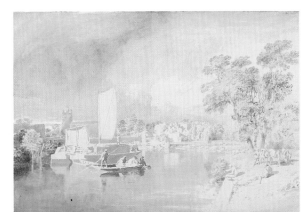

ON DISPLAY
This watercolor
box was made
for the exhibition
"Works of Industry
of All Nations"
(London, 1851).
By this date, the
medium was
highly popular.

**A FRANK
ENCAMPMENT
IN THE DESERT OF MOUNT SINAI, 1842**
*John Frederick Lewis; 1856; 25¼ x 52¼ in
(64.5 x 134 cm); watercolor and bodycolor*

Winsor and
Newton box

Lewis's light effects and bright colors influenced the Pre-
Raphaelites. He later turned exclusively to oils, and in doing
so effectively marked the end of the large exhibition watercolor.

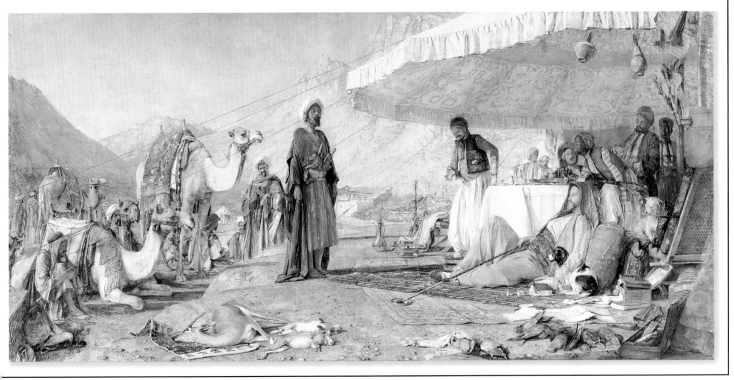

A genteel pursuit

D URING THE 18TH AND 19TH CENTURIES an ability to draw became widely regarded as an admirable skill for young ladies and gentlemen. As an activity it had a status similar to that of dancing, fencing, or needlework. By the late 18th century, watercolor materials were readily available. For the amateur, painting in water-colors was easier to master, and cheaper, than oils. People often sought tuition from drawing masters or professional artists, whose style they invariably followed. Instruction manuals were also produced at this time by well-known artists. In 1811, David Cox (pp. 9, 33) published *A Series of Progressive Lessons*, and in 1857, John Ruskin (p. 15) wrote *The Elements of Drawing*.

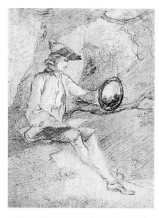

MAN WITH A CLAUDE GLASS
Thomas Gainsborough drew this around 1750. These popular drawing aids reflected the country-side so that it looked like landscape paintings by old masters.

A LUXURIOUS ACCESSORY
This decorated silver water bottle and brush carrier was made for a lady in the late 18th or early 19th century.

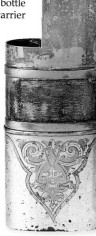

Two Women Drawing Amidst Classical Ruins

HUBERT ROBERT *1786; 27½ x 38½ in (70 x 98 cm); pen and watercolor*
Here, two ladies are shown lightheartedly sketching the vast ruins of Rome while, unknown to them, the spirits of the ancients watch from behind a column. At this time, Rome was an extremely popular subject with amateurs and professionals alike. In 1830, the artist Thomas Uwins wrote with disgust from the ancient city: "What a shoal of amateur artists we have got here!"

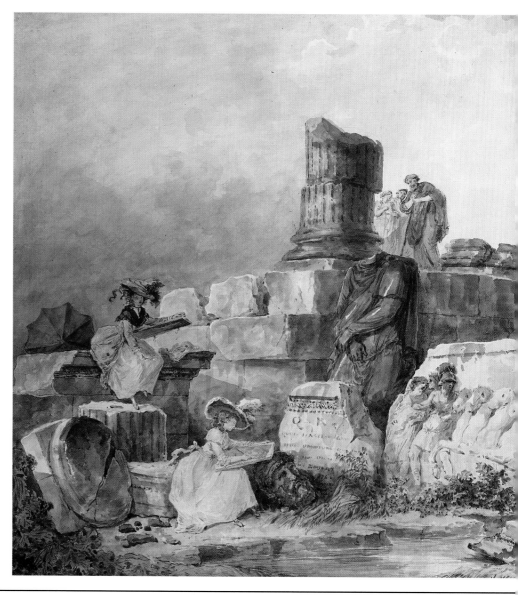

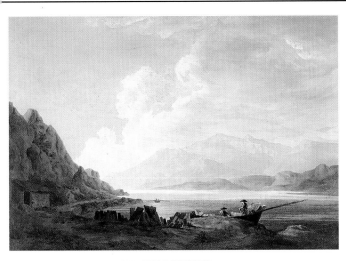

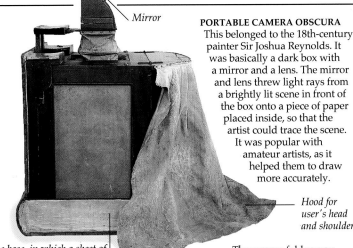

This belonged to the 18th-century painter Sir Joshua Reynolds. It was basically a dark box with a mirror and a lens. The mirror and lens threw light rays from a brightly lit scene in front of the box onto a piece of paper placed inside, so that the artist could trace the scene. It was popular with amateur artists, as it helped them to draw more accurately.

Mirror

Hood for user's head and shoulders

The base, in which a sheet of drawing paper was placed

The camera folds away to look like a large book

VIEW OF SNOWDON AND LAKE LLANBERIS
Reverend Thomas Gisborne; 1789; 16¼ x 11½ in (41 x 29 cm); watercolor
During the 18th and 19th centuries, a considerable number of clergymen emerged as accomplished watercolorists. Gisborne (1758–1856) was acquainted with the painter Joseph Wright of Derby, and the two men often went on sketching expeditions together to natural beauty spots, such as the Lake District in the north of England. Gisborne also corresponded with the Reverend William Gilpin, who was the author of various books on good destinations for sketching tours in Britain.

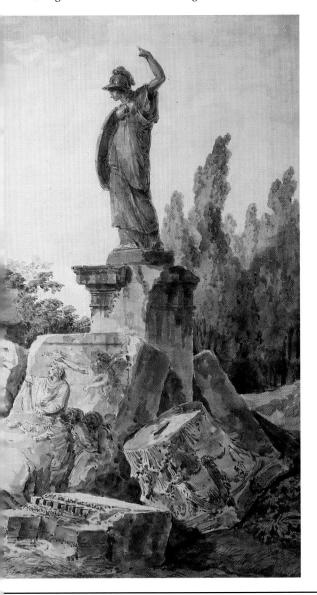

A SKETCHING PARTY IN LEIGH WOODS
Samuel Jackson; c.1830; 17¼ x 25¾ in (44 x 66 cm); watercolor and bodycolor
Jackson (1794–1869) was a successful drawing master who belonged to the Bristol School – a community of professional and amateur artists who lived and worked around England's major southwestern city, during the 19th century. This scene shows a sketching class in Leigh Woods, outside Bristol. In his watercolor paintings, Jackson developed a technique using sponging, scratching, and thin glazes of bodycolor.

THE LAMENT OF A DRAWING MASTER
This detail shows the more frivolous side of a sketching expedition – one woman is playing the guitar. By the 19th century, the art teacher tutoring bored young girls had become a literary stereotype. In a story called *The Old Drawing Master*, the teacher Monsieur "La Trobe" laments, "You are all sweet, kind young ladies, you very sweet, and good, ven you not draw, and monche, monche de tops off your crayons, and lose Engee rubbere and mark skies green."

The "mystics"

WILLIAM BLAKE
Blake claimed to have had his first vision – of "a tree filled with angels" – before the age of ten.

THE VISIONARY ART of William Blake (1757–1827), and of other "mystical" artists of the time, was more suited to relatively private media such as watercolor than to grand public statements in oils. Blake painted many watercolors and also used the medium to color his prints. He was a highly individual artist, who believed that ideal beauty came from within, without reference to nature. Also a great poet, much of Blake's visual output was produced to illustrate his poems, and his integration of word and image is evocative of medieval illumination (pp. 10–11). His work influenced the "Ancients" – a group centered on the artist Samuel Palmer, who admired visionary art from the past.

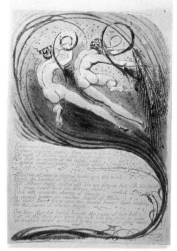

MILDEW BLIGHTING CORN
William Blake; c.1821;
12¼ x 9½ in (32 x 24.5 cm); etching
This plate comes from Blake's own poem, entitled *Europe, a Prophecy,* which revealed his predictions on the fate of Europe. Blake prepared a finely watercolored edition of this etching for his patron, John Linnell.

ILLUSTRATIONS FOR
NIGHT THOUGHTS
William Blake; c.1795–98;
pen and watercolor
Blake painted over 500 watercolors for Edward Young's book *The Complaint, and the Consolation; or Night Thoughts* (1742–45). As usual, Blake's imagery is complex. His images dominate the text, as in a lavish illuminated manuscript.

Jacob's Dream
WILLIAM BLAKE
c.1800–03; 14½ x 11½ in
(37 x 29 cm); watercolor
Here, Blake gives concrete form to a visionary scene. He shows Jacob's dream of God as told in the Old Testament – a vision of God's angels ascending and descending a ladder between heaven and earth.

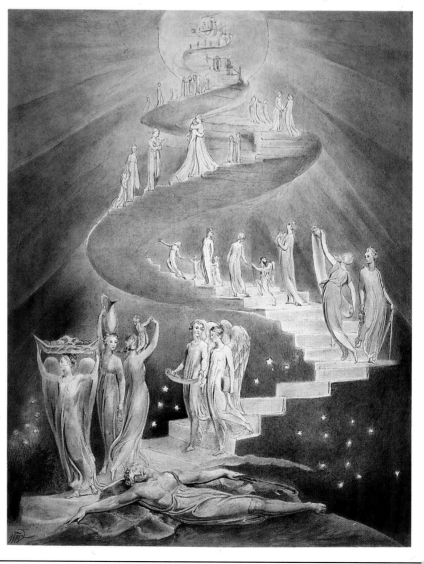

THE HERDSMAN
Samuel Palmer; c.1855; 20½ x 29 in (52 x 73.5 cm); watercolor
This lyrical work on buff paper is Palmer's idealized vision of the English countryside. Palmer (1805–81) mixed gum arabic and bodycolor to achieve an almost oil-like effect, painting in washes or, more delicately, with the point of the brush.

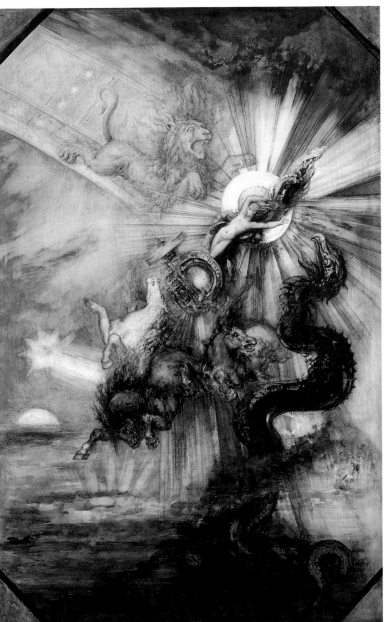

PORT STRAGGLIN *above*
Richard Dadd; 1861; 7½ x 5½
in (19 x 14 cm); watercolor
Richard Dadd's eccentric,
mystical art was born of
madness. From 1844, he
was confined to Bedlam
Hospital for the murder
of his father. He had
previously traveled in
Greece, Egypt, and the
Middle East, and *Port
Stragglin* may have been
based on some of the
stranger sights he had
seen there. His technique
was delicate, using the
pointed tip of the brush.

PHAETON
Gustave Moreau; 1878; 39 x 25½ in
(99 x 65 cm); watercolor and pencil
This lurid work, heightened further
by white paint and varnish, was
exhibited at the 1878 World's Fair in
Paris. It shows Phaeton's fall from
the sky, as punishment for stealing
the chariot of Apollo. In addition to
making preparatory watercolor
sketches for most of his oils, Moreau
(1826–98) valued the medium for its
own sake. He produced over 400
watercolors. Moreau believed that
colors could have a powerful
emotional value, and he has used
them in this painting to evoke a
highly dramatic and tragic scene.

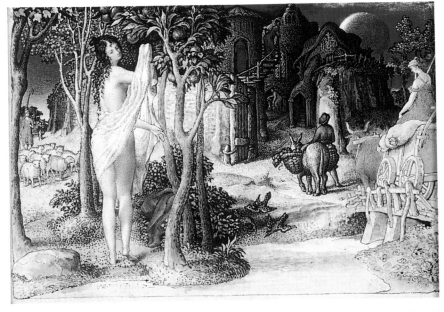

A PRIMITIVE CITY
Edward Calvert; 1822; 2¾ x 4 in (7 x 10.5 cm); pen and watercolor
Like Palmer, Calvert (1799–1883) had been one of the
youthful disciples of Blake known as the Ancients.
Calvert based the design of small, exquisite prints and
watercolors such as this on Blake's illustrations to
Thorton's *Virgil*. He conjures up, almost as in an
illuminated manuscript, an innocent,
imaginary world of female beauty
and bountiful nature.

IN DETAIL
The donkey and his
master lead the
procession into
the city, laden
with produce.
Calvert's water-
color technique is
closely based on Palmer's
earlier work. Pen outlines
play an important part and
give an almost speckled effect.

Book illustrations

COLOR BOOK ILLUSTRATION originating from watercolor artwork is a relatively new art form. It grew out of the development of sophisticated color printing techniques, during the second half of the 19th century. Before this, printers had not been able to reproduce original watercolors accurately. In the 18th century, the initial artwork for color engraving had to be designed in black and white; color was added as a later process. The traditional use of water-color for hand-coloring black-and-white prints (p. 30) made it a natural medium for illustrators. The late 19th and early 20th centuries became the golden age of children's book illustration in England. Certain highly popular illustrators gained celebrity status, and the major London publishing companies competed with their top children's artists.

GIRL AND TWO BABIES
Kate Greenaway; c.1870s; 7¼ x 4¾ in (18 x 12 cm); pen and watercolor
Greenaway's illustrations of children in 18th-century dress – partly of her own invention – were extremely popular in late-Victorian England. Kate Greenaway (1846–1901) started out doing drawings for cards and children's magazines. In 1870, the color printer Edmund Evans commissioned her to illustrate books of her own poems. Evans used several colored printing blocks – red, flesh tint, blue, and yellow – to reproduce the quality of the original watercolors.

CINDERELLA
Artist unknown; c.1876; 5½ x 5½ in (14.5 x 14.5 cm); watercolor
Fairy tales were a popular choice for mass-produced books. This book, featuring *Cinderella* and *Little Red Riding Hood*, has surprise pictures hidden under movable flaps.

OLIVER TWIST *right*
George Cruikshank; 1866; 4 x 3¾ in (10 x 9.5 cm); pencil and watercolor
Cruikshank began as a political cartoonist and later became the first artist to illustrate children's books humorously. He was the ideal collaborator for Charles Dickens, whose characters were often caricatures.

WUTHERING HEIGHTS
Edmund Dulac; 1905; 8½ x 6½ in (22 x 16.5 cm); watercolor
Dulac (1882–1953) trained in Paris as a painter before becoming an illustrator. In his own words he was "fascinated by pigment and color" and was also greatly influenced by Art Nouveau (a highly ornate style that spread across Europe and the United States in the 1890s). He used color almost entirely for its decorative effect, working carefully from pencil-drawn foundations. This is part of a series of watercolors that Dulac produced to illustrate a complete set of novels by the Brontës.

WINNIE-THE-POOH

Ernest H. Shepard; 1926; pen and watercolor

Shepard (1879–1976) was one of the most successful illustrators from the inter-war years – his images of Pooh are better known than A.A. Milne's stories. First published in 1926, the Pooh illustrations were given a new wash by Shepard in 1973-74.

TREASURE ISLAND

Salomon van Abbé; 1948; 14¾ x 10½ in (37.5 x 27 cm); pencil and watercolor

This is one of several drawings made for a 1948 edition of Robert Louis Stevenson's novel, which was first published in 1883. A scene of action, its main characters are shown in period costume. Conventional in style, it indicates the continuing demand for traditional watercolor illustrations in classic children's books.

THUMBELINA

Joan Charleton; 1960; 11¾ x 15¾ in (30 x 40 cm); pen and watercolor

This illustrates Hans Christian Andersen's 19th-century fairy tale about Thumbelina, the miniature child. Although probably reproduced with modern printing techniques, in which a watercolor is "read photographically," the finished result is stylistically similar to that of early color illustrations such as Cinderella (p. 44). A commercial rather than a "fine art" illustration, it is designed to appeal to a wide range of children.

THUMBELINA ENLARGED

Although Thumbelina is tiny, the illustrator turns the other figures (above) to look at her, making her central to the story, and to the picture.

RUPERT THE BEAR

Mary Tourtel; 1931; watercolor

Rupert was created in 1920 by the children's illustrator Mary Tourtel, as a comic strip for *The Daily Express*. Almost immediately, Rupert memorabilia and pop-up annuals, such as this, were produced in response to his popularity. Tourtel retired in 1936 and has since been followed by several generations of illustrators. In the 1970s and '80s, animated cartoons were made about Rupert and his friends. An effort has been made to keep Rupert true in his essential features and colors to Tourtel's original watercolors.

Rupert is shown in his original clothes: blue jumper, gray-check trousers, and scarf

POP-UP RUPERT

This pop-up annual, featuring Rupert the Bear, was published by the *Daily Express* newspaper in 1931. The *Daily Express* Rupert annuals became a much-loved institution.

The Pre-Raphaelites

DANTE GABRIEL ROSSETTI (1828–82), Sir John Everett Millais (1829–96), and William Holman Hunt (1827–1910) formed the Pre-Raphaelite Brotherhood in 1848. They aspired to a "pure" style that they felt existed prior to the Italian artist Raphael (1483–1520). Medieval and literary themes were stressed, and in covering these in their watercolors, they moved away from typical watercolor subjects, such as landscape. They favored areas of flat, vivid color and extremely fine, sharply focused details, which they picked out with bodycolor.

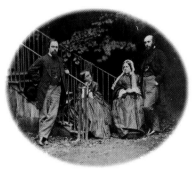

A FAMILY PORTRAIT
Dante Gabriel Rossetti is on the extreme left of this 1863 family photograph.

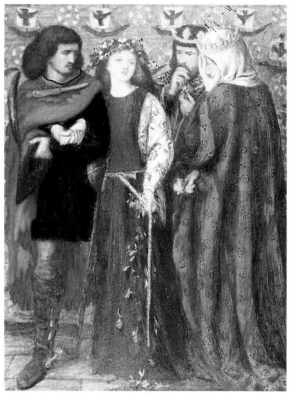

HORATIO DISCOVERING THE MADNESS OF OPHELIA
Dante Gabriel Rossetti; 1864;
15½ x 11½ in (39.5 x 29 cm); watercolor and bodycolor
Until 1860, Rossetti worked primarily in watercolor. This painting has a two-dimensional quality, emphasized by the shields in the background that are brought forward by their bold colors. The tragic suicide of Ophelia, in Shakespeare's *Hamlet*, was echoed in Rossetti's own life – his wife, Elizabeth Siddal, died from an overdose of the drug laudanum.

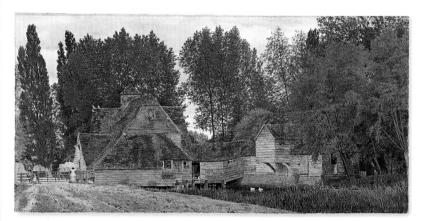

THE MILL ON THE THAMES AT MAPLEDURHAM
George Price Boyce; 1860; 10¾ x 22¼ in (27.5 x 57 cm); watercolor
An architect by training, Boyce (1826–97) often filled his landscape paintings either with trees, or with buildings, as he has done here. He achieved his brilliant tones and sharp details, which were typical of Pre-Raphaelite landscapes, by preparing his paper first with a layer of gum.

CHAFFINCH NEST AND MAY BLOSSOM
*William Henry Hunt; c.1845; 9½ x 14¾ in
(24.5 x 37.5 cm); watercolor and bodycolor*
Hunt's watercolors encouraged many artists to paint in bodycolor; they were avidly collected by the Victorian public. He created luminous effects by starting with a hard surface of gum mixed with Chinese white, then painting in pure watercolor.

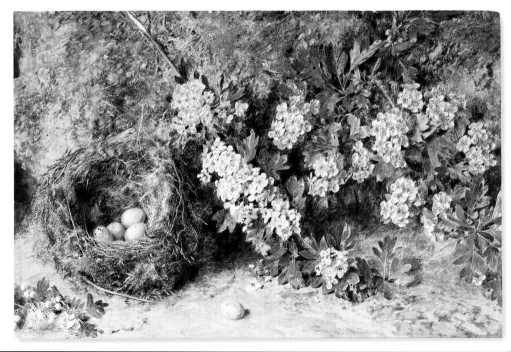

HIGHLIGHTED DETAIL
Hunt used Chinese white for highlights and for reflected light – here, he mixed pigments into the white to make the eggs rich in tone and opaque in color.

Phyllis and Demophoön

SIR EDWARD COLEY BURNE-JONES
1870; 36 x 18 in (91.5 x 46 cm); watercolor and bodycolor

Burne-Jones (1833–98) took this subject from *Heroides*, by the Roman writer, Ovid. In the story, Demophoön's lover, Phyllis, is changed into an almond tree. Burne-Jones's figures echoed those of the 15th-century Florentine artist Sandro Botticelli. Some of the criticism leveled at this picture when it was first shown was due to the nudity of the male figure.

SIR EDWARD COLEY BURNE-JONES
Along with William Morris (pp. 48–49), Burne-Jones headed the second wave of Pre-Raphaelitism. Shown here in 1890, he designed items such as wallpapers and tapestries for the firm of Morris, Marshall, Faulkner and Co.

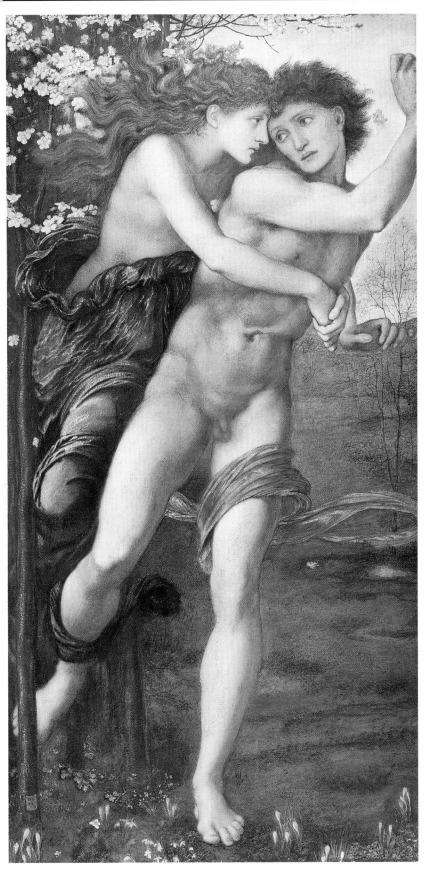

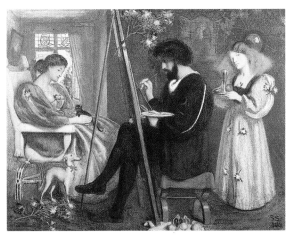

THE PAINTER'S PLEASURE
Simeon Solomon; 1861; 10 x 13 in (25.5 x 33 cm); watercolor and bodycolor
This painting shows an episode in the life of an imaginary Venetian painter of the Renaissance. Solomon (1840–1905) used a rich watercolor technique, similar to Rossetti's, in this work. The paint (mainly bodycolor) was applied fairly dry over monochrome (one-color) underpainting and then scraped out with a knife to create highlights. A gum arabic varnish was also applied to the painting.

The flat painting technique used in *Phyllis and Demophoön* makes it seem almost like a rich tapestry

THE HOLY CITY *right*
William Holman Hunt; c.1854; 7½ x 13½ in (19.5 x 34.5 cm); watercolor and bodycolor
This painting of Jerusalem is the result of one of Hunt's trips to Egypt and Palestine, during which he painted largely in watercolors. His Eastern watercolors are most notable for their deep colors, particularly indigo and purple.

A company of craftsmen

W ILLIAM MORRIS (1834–96) was a major figure in the second wave of Pre-Raphaelitism (pp. 46–47). His talent was for design and pattern, and the firm that he founded in 1861 – Morris, Marshall, Faulkner and Company – had London showrooms that sold furniture, tapestries, metalwork, stained glass, jewelery, wallpaper, and fabrics. He employed various artists to produce beautifully detailed watercolors as preparatory designs. Like the other Pre-Raphaelites, the style and approach of his work looked back to simpler times. Reacting against the industrialization of Victorian society, he based his company on a medieval guild of skilled craftsmen making high-quality items by hand.

PORTRAIT OF WILLIAM MORRIS
Cosmo Rowe; c.1895; 15 x 11 in (39 x 29 cm); oil on canvas
Morris was born in north London, the son of a wealthy broker. After attending Oxford University, where he met Burne-Jones (p. 47), he turned to architecture, and then to painting, before starting his company.

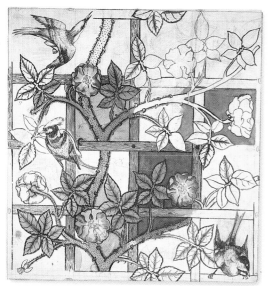

DESIGN FOR "TRELLIS" WALLPAPER
1862; 26 x 23 in (66 x 58.5 cm); watercolor and pencil
This was the first of 70 wallpaper designs from Morris's workshop. It was derived from a wooden trellis at his home, the Red House at Bexleyheath, southeast of London. Designs were often the work of a number of people; here the birds were drawn by Philip Webb.

DESIGN FOR "TULIP" FABRIC *right*
1875; 18 x 10 in (45.5 x 25.5 cm); watercolor and pencil
Watercolor was ideal for working out designs, rapidly producing broad washes of color, through which pencil sketches could still be seen.

The basic pencil design is still clearly visible beneath the washes of watercolor

Wooden printing block

Cotton printed with "Tulip" design

"TULIP" PRINTING BLOCK AND "TULIP" DESIGN FABRIC *left*
Once finalized, the design was cut out of a wooden block – usually pear wood. Here, an original block (12 x 9 in / 32 x 24 cm) and printed fabric are shown. To print onto fabric, dye was applied to the block by hand, as Morris stressed traditional methods. One color was printed at a time.

Design for the "Pomona" Tapestry
WILLIAM MORRIS & SIR EDWARD BURNE-JONES
c.1884; 15¾ x 11¾ in (40 x 30 cm); watercolor

Pomona was a Roman goddess of *poma*, the Latin word for "fruits." The figure of Pomona was drawn by Burne-Jones. Morris added her costume, the background, the decorative border, and the scrolls of text. Morris usually worked with collaborators on his tapestry designs.

THE NATURAL WORLD
This detail is taken from the bottom left of the design. Morris's love of all kinds of natural forms is once again evident here. The borders and background of this watercolor are almost reminiscent of a medieval herbal (pp. 14–15) in the detail with which the flowers and leaves have been painted.

MEDIEVAL VALUES
As this design shows, the work of Morris and his associates was inspired by the intricate details and rich colors of the art of the late Middle Ages. Morris sought to re-create a more innocent, natural age: "To turn our chamber walls into the green woods of the leafy month of June, populous of bird and beast; or a summer garden with man and maid playing round a fountain, or a solemn procession of the mythical warriors and heroes of old; that surely was worth the trouble of doing."

The watercolor paint effectively conveys both deep shadows and sunlit highlights on this border of grapes

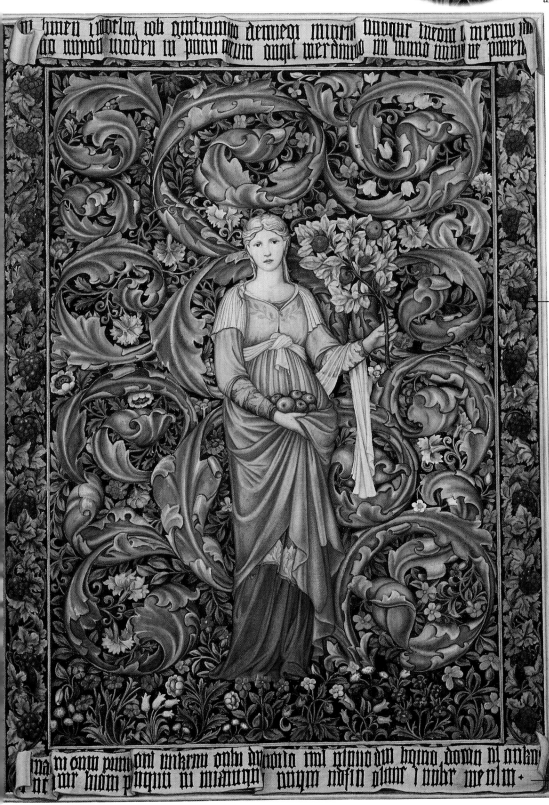

A PORTRAIT OF POMONA
The face of Pomona, drawn by Burne-Jones, has the look of many of the women in paintings by the Pre-Raphaelites (pp. 46–47). As with Burne-Jones's other work (p. 47), it also shows similarities to the paintings of Botticelli. The watercolor has been used so that it gives Pomona's skin a convincing ivory translucence, rather like some of the effects achieved by earlier miniature painters (pp. 22–23).

The way in which the scroll has been painted gives a strong three-dimensional feel

Impressionism

W<small>ATERCOLOR</small> was frequently used by the Impressionists, whose style tended to suppress outline in favor of brilliant areas of color. The group's preoccupations with light effects and with painting outdoors also made the medium and its techniques attractive. The first Impressionist exhibition, held in Paris in 1874, signified a break with classical and historical subjects, which were traditionally executed in oils. While oil painting did remain the central activity of the Impressionists, watercolors were included in all eight of their group exhibitions. During the economic depressions of the 1880s, watercolors rather than oil paintings were often produced in response to dealers' demands for less expensive works.

WOMAN OF ALGIERS
Eugène Delacroix;
1832; 7½ x 5 in
(19.5 x 13 cm); watercolor
A great influence on the Impressionists, Delacroix filled his travel journals with outdoor studies.

PORTRAIT OF BERTHE MORISOT
Edouard Manet; 1874; 8 x 6½ in (20.5 x 16.5 cm); watercolor
Manet's extremely fluid manner of painting in watercolor is clearly in evidence. Forms are painted, rather than drawn, and thinned washes are allowed to run into one another over the ivory paper. The painting exudes a feeling of confidence that reflects how at ease Manet (1832–83) was with the paint. Morisot married Manet's younger brother Eugène. Here, she wears black in mourning for her father, who had died that year.

CARRIAGE IN THE BOIS DE BOULOGNE *left*
Berthe Morisot; 1889; 10 x 8¾ in (25 x 22.5 cm); watercolor
Most of the watercolors by Morisot (1841–95) dealt with female family members. However, here she evokes the atmosphere and light of a fashionable area of Paris, using highly diluted washes of color to give the subtlest suggestion of shape, volume, and light. The choice of contemporary subject matter is typical of an Impressionist. Unlike the art that went before it, Impressionism sought to portray modern life and society, rather than historical, mythological, or religious subjects.

Girl in a Field with Turkeys
CAMILLE PISSARRO
1885; 25¼ x 7¾ in (64 x 20 cm); gouache on silk fan
Pissarro's interest in painting fans was strongly stimulated by the contemporary fascination with Japanese art. Painted on silk, the gouache has been laid on heavily so that the fan is not transparent. Pissarro (1831–1903) experimented with a number of painting styles throughout his career, concentrating in particular on watercolor painting during the 1880s.

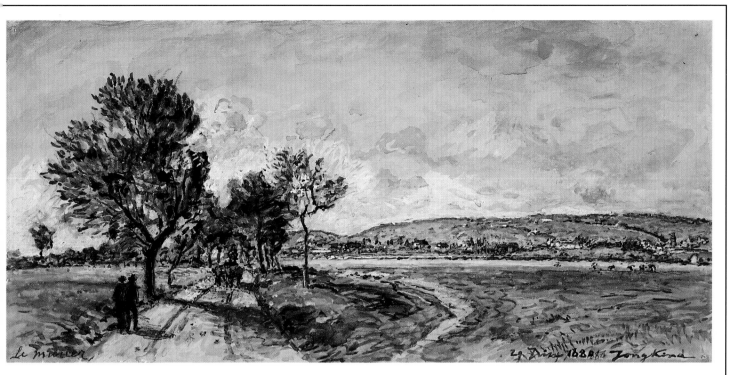

LANDSCAPE NEAR LA CÔTE-ST-ANDRÉ (DAUPHINÉ)

Johan-Barthold Jongkind; 1880; 5½ x 9¾ in (14 x 23 cm); watercolor and bodycolor over black chalk

Jongkind was an important precursor of Impressionism, and his broad, sweeping landscapes influenced many artists, including the young Monet, in the early 1860s. A group of paintings composed after 1863 was described by the theorist Paul Signac as "the finest series of watercolors in the world." Jongkind was a prolific watercolorist, who enjoyed painting the coasts of France and Holland. His vigorous, broken touch is clear in works such as this view of south-eastern France.

GONDOLIERS AT VENICE

Jean-Louis-Ernest Meissonier; 1870; 11¼ x 16¼ in (29 x 41.5 cm); pencil, watercolor, and gouache

Meissonier shared many of the Impressionists' artistic interests, although he was not strictly a member of their group. He was, like them, preoccupied by the portrayal of light. An accomplished watercolor painter, he recalled, "I no longer like painting in oils; nothing is as agreeable as watercolor."

TAHITIAN LANDSCAPE

Paul Gauguin; 7½ x 11¾ in (19 x 30 cm); watercolor

This richly colored sketch is taken from *Noa Noa*, Gauguin's journal of his first voyage to Tahiti in 1891. Here, Gauguin (1848–1903) chose watercolor to express his intense reaction to the South Pacific.

Cézanne – art and light

PAUL CÉZANNE (1839–1906), one of the most influential painters of the 19th century, pointed the way forward from Impressionism toward Abstraction (pp. 50, 60). Watercolor was just as important to him as oils – his many watercolors were rarely related to his oil paintings, and developed in parallel. The medium suited his love of color and light, and he was increasingly drawn to its transparency, using much less opaque color in his later work. His distinctive approach included allowing one color to dry before laying a second on top – he seldom let colors run together. This gave Cézanne's watercolors a glow, as one color shone up through another.

PROVENÇAL ARTIST
Although he associated with the Impressionists in Paris early on, Cézanne spent most of his life in his native Aix-en-Provence, in the south of France.

MAN WEARING A STRAW HAT
Paul Cézanne; 1906; 19 x 12½ in (48 x 31.5 cm); pencil and watercolor
In his late watercolors, such as this one, Cézanne achieves a striking luminous quality. Color is laid over the white paper surface, which shines through and enhances the sense of light playing over the surfaces.

THE THREE BATHERS
Paul Cézanne; 1874–75; 4½ x 5 in (11.5 x 12.5 cm); pencil, watercolor, and gouache
Cézanne's bathers are often seen as an attempt to re-create the classical idea – which was revived in the Renaissance – of beauty in nature. The untidy outlines and frenzied application of color, however, are far removed from classical balance and calm.

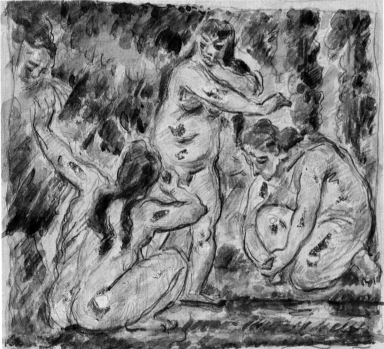

MARKS OF TIME
White paint has been used to "heighten" (highlight) the bodies. These white patches have been discolored by oxidization.

THE MOUNTAIN OF SAINTE-VICTOIRE
Paul Cézanne; 1885–87; 12½ x 18¾ in (31.5 x 47.5 cm); pencil and watercolor
With just a few inspired strokes of color, Cézanne manages to convey the mighty form of the mountain that overlooks Aix-en-Provence and is the main landmark of this region. He painted it many times, and this view is from the southwest, looking over the valley of the Arc river.

Still Life with Apples, Bottle, and Chairback

PAUL CÉZANNE

1902–06; 17½ x 23¼ in (44.5 x 59 cm); pencil and watercolor

Cézanne was a slow, careful worker, so still lifes provided him with ideal material. However, his still lifes have an energy not normally associated with such subject matter. Forms seem to balance precariously on one another, and spatial relationships are often slightly ambiguous. It is as though the whole composition is about to rearrange itself.

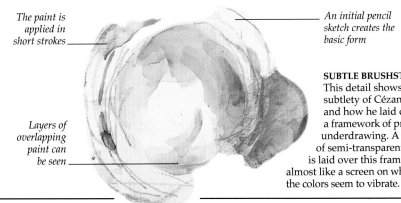

The paint is applied in short strokes

An initial pencil sketch creates the basic form

Layers of overlapping paint can be seen

SUBTLE BRUSHSTROKES
This detail shows the subtlety of Cézanne's touch, and how he laid color over a framework of preliminary underdrawing. A patchwork of semi-transparent colors is laid over this framework, almost like a screen on which the colors seem to vibrate.

The nude in watercolor

THE UNCLOTHED HUMAN BODY has been portrayed in Western art since classical times. To the ancient Greeks and Romans, it represented the perfection of their gods, while during the Middle Ages, nakedness spelled human guilt – Adam and Eve's expulsion from Paradise. For watercolor artists, the nude offers a chance to use the medium to stunning effect. Watercolor requires rapid execution, and a few swift strokes can capture the basic lines of the body in a way that is both graceful and dramatic. It is also an ideal medium for depicting the soft sheen of skin – by leaving areas of paper unpainted, or by letting the paper shine through its transparent washes.

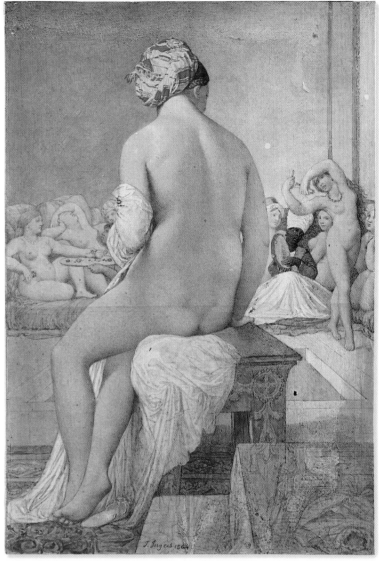

PAINTING UNDER DIFFICULTIES
Thomas Rowlandson; date unknown; 8½ x 11¼ in (22 x 28.5 cm); pen and watercolor
Rowlandson (1756–1827) here pokes fun at the tradition of male artists drawing and painting from naked female models. Caught in one woman's embrace, the artist is so distracted that he finds it difficult to paint. The models are shown as plump and voluptuous, according to the fashion of the time.

THE TWO FRIENDS
Jules-Robert Auguste; c.1800–25; 9 x 10¼ in (22.5 x 26 cm); watercolor and gouache
One of several Auguste paintings of black and white nudes together, this was undoubtedly meant to appeal to collectors of mild erotica. It is typical of his watercolors in being highly finished and coated with gum arabic varnish to give it an extra richness.

Odalisque

JEAN AUGUSTE DOMINIQUE INGRES *1864; 13½ x 9¼ in (34.5 x 23.5 cm); watercolor*

This exotic work shows an odalisque – an Eastern slave or concubine – in a Turkish bath. It is a reworking of earlier oil paintings produced by Ingres (1780–1867). The French artist has used watercolor to give these nudes the sensual quality that appeared in his oils of the same subjects. The watercolor has lent soft highlights to the smooth skin of the main nude – which is painted with the idealization evident in much of Ingres's work.

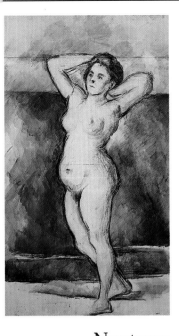

RECLINING FEMALE NUDE *right*
Oskar Kokoschka; 1922; 20 x 27 in (52 x 70 cm); watercolor
The nude drawings of the Austrian Expressionist Kokoschka (1886–1980) show a wonderfully free disregard for conventions of form. He has painted this with the uninhibited strokes of a brush loaded with thinned watercolor. The body can only just be made out, yet this loosely modeled work exudes sensuality.

STANDING FEMALE NUDE *left*
Paul Cézanne; 1898–99; 35 x 21 in
(89 x 53 cm); pencil and watercolor
This late watercolor is unusual for Cézanne; he rarely painted single nudes (pp. 52–53). He has deliberately left areas unpainted, so that much of the creamy color of the woman's body is provided by exposed paper.

Neptune
AUGUSTE RODIN *1890;*
12¾ x 9½ in (32.5 x 24.5 cm);
pencil and watercolor
Rodin produced a huge number of rapidly executed pencil drawings of nudes, and to many of these studies he added watercolor wash. He used the paint sparingly, but achieved the maximum effect. In this drawing of the Roman god of water, the dark watercolor added for the hair and beard lends a softness that contrasts with the spare lines of the body.

AUGUSTE RODIN (1840–1917)
Rodin was principally a sculptor, and his figures have a dynamism far removed from the frozen lifelessness of much "academic" sculpture. Also a prolific draftsman, the French artist's frank, unconventional drawings of nudes had a considerable influence on artists as diverse as Gustav Klimt and Henri Matisse.

Modern uses of the medium

ELEMENTS OF DESIGN
This house is a detail from a chintz design by Charles Voysey (see below). Voysey was an architect, famous for designing houses in this style. The watercolor is used to provide general washes of color, and to pick out small, vivid details.

IN THE 20TH CENTURY, watercolor's versatility has ensured that it has had many applications outside the world of "fine art." It has often been used in advertising, to convey a specific atmosphere – the railroad poster on p. 57 uses the gentle associations of traditional watercolor landscape painting to conjure up an idyllic rural image. Despite the growing role of computers in design, watercolor is still of particular value in the preparatory stages of designing all kinds of projects – from stage sets to high fashion. For designers, working with such a fluid medium makes them feel more involved in the act of creation, and its low cost and accessibility add to its appeal. For prospective clients, or the public, the bright, sparkling qualities of watercolor make it instantly attractive. These pages show how watercolor continues to fulfill its varied potential.

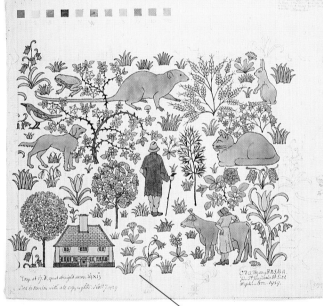

DESIGN FOR A NURSERY CHINTZ
Charles Voysey; 1929; 19¼ x 23¼ in (49 x 59 cm); pen, pencil, and watercolor
Voysey's watercolor illustrates the popular nursery rhyme, *The House That Jack Built*.

This faint drawing is a caricature of Voysey's brother, who was a Unitarian minister

It is a preparatory design for a printed cotton fabric intended for use in a nursery. The paint has been applied with skill, and the light, bright colors that can be achieved with watercolor convey this nursery theme particularly well. Voysey (1857–1941) was an influential domestic architect who also designed furniture, fabrics, and wallpapers, in the same tradition as William Morris (pp. 48–49). As with much of Morris's work, the detailed plants and animals are reminiscent of medieval manuscripts (pp. 10–13).

Model for *Le Comte Ory* ("Count Ory")

OLIVER MESSEL *1954; 24 x 36 in (61 x 91 cm); model painted in watercolor*
This model is a set design for a 1954 production of Rossini's opera of 1823. Some of the details for the medieval setting, for example, on the castle, were adapted from medieval tapestries. The story concerns a countess and her companion who are left behind in a castle when their men go off to the Crusades. Count Ory and his men enter the castle disguised as nuns, but the crusaders return and resolve the situation. Once again, watercolor shows its ability to convey both broad scenic effects, and finer details such as animals and foliage.

**DESIGN FOR THE CORNICHE
MOSQUE, JEDDAH, SAUDI ARABIA**
*Abdel Wahed El-Wakil (architect) and Edwin Venn (artist);
1989; 9¾ x 11¾ in (25 x 30 cm); watercolor and pencil*
El-Wakil, an Egyptian architect, designed the Corniche
Mosque as part of a beautification program for Jeddah. It is set
on a large, isolated sand dune above a coral reef. Watercolor is
particularly suitable for illustrating buildings because the lines
of a basic design can remain visible beneath the washes. It is an
appealing way of presenting designs to clients – El-Wakil has
commissioned Venn to paint many of his building designs.

RAIL POSTER
Frank Sherwin; c.1955; 40 x 50 in (16 x 19.5 cm); gouache
The rail posters designed by commercial artist Frank Sherwin before and after World
War II were highly successful. Many 20th-century British Railways posters worked so
well because they celebrated the countryside through which trains traveled, not the trains
themselves. Here, the popular watercolor landscape is used to evoke an idealized English
scene. This was Sherwin's favorite medium, and
many of his watercolors were reproduced
by greeting card manufacturers.

This cloak, worn by the witch in
Hansel and Gretel, shows the
children that she has eaten!

**CLOAK DESIGN FOR
*HANSEL AND GRETEL***
*Terry Francis Parr (designer)
and Roger A. Oakes (painter); 1990;
water-soluble paints on fabric*
This costume was created for
a production of Humperdinck's
opera. It is painted with water-
soluble paints that bond to the
fabric when the garment is ironed.

FASHION DESIGN
*Emma Mandell-Lynn; 1992;
11½ x 16½ in (29.5 x 42 cm); watercolor*
Like many clothing designers, Mandell-Lynn
works out her designs in watercolor. She often
builds up a design in cut-out pieces of paper
painted in watercolor and then stuck together.
Gouache, with its strong coloring, is used for
details and finished designs, while transparent
color is employed for spontaneous ideas.

**THE PERFECT
MEDIUM**
Mandell-Lynn
finds water-
color fast,
simple to use,
fluid, and
easy on the
eye. She feels
that it is ideal
for "getting a
whole look
across."

Expressionism

T HE EXPRESSIONISTS' watercolors contradict any reputation that the medium may have for being "safe" or purely descriptive. The main purpose of art for the Expressionists was to express emotion, and they set out to do this by exaggerating line, color, and form. This approach was directly opposed to Impressionism (pp. 40–41) and its strong emphasis on painting from life. Although there was a parallel movement in France (Fauvism), Germany became the center of Expressionism and two main groups were formed there. The first was called *Die Brücke* ("The Bridge") and included Emil Nolde (1867–1956). Founded in Dresden in 1905, it lasted until 1913. The second was *Der Blaue Reiter* ("The Blue Rider"). This was formed in Munich and the Germans Franz Marc (1880–1916) and August Macke (1887–1914) were prominent members.

RUSSIAN PRISONER OF WAR
Egon Schiele; 1916; 17¼ x 12 in (44 x 31 cm); pencil and gouache
Schiele (1890–1918) "colored in" this drawing with gouache. Line was an important aspect of his work.

TWO BLUE HORSES IN FRONT OF A RED ROCK
Franz Marc; 1913; 5½ x 3½ in (14 x 9 cm); tempera
Marc, who sent this as a postcard to the Russian artist Kandinsky (p. 60), believed in color's power of expression. He wrote of his unusual choice of colors: "Blue is the male principle ... Red is matter, brutal and heavy ..."

ST. GERMAIN, NEAR TUNIS
August Macke; 1914; 10¼ x 8¼ in (26 x 21 cm); watercolor
Macke painted this on a visit to Tunisia with the artist Paul Klee (p. 61). Like many Expressionists, Macke had a keen interest in color and form. In this painting, he showed the distant Tunisian mountains as blue pyramids. The effect was achieved by his application of three dominant, overlapping blue washes.

THE COUPLE
George Grosz; c.1922–24; 22½ x 18 in (57.5 x 46 cm); watercolor and ink
This sums up political satirist Grosz's contempt for 1920s Germany. An Expressionist in intensity of feeling, his use of watercolor was extremely informed, and aided his bitter attacks on contemporary German society.

Sunflowers
EMIL NOLDE
c.1937; 10½ x 9 in (27 x 23 cm); watercolor
Although a member of *Die Brücke* and an exhibitor with *Der Blaue Reiter*, Nolde had an extremely individual approach to his art. This is particularly true of his watercolor technique. He used a thick, highly absorbent rice paper, soaking it in water so that, when he applied paint, the colors saturated the page – "floating" into one another. In some of his paintings, the paper became so saturated that the picture was also visible on the reverse, making the two sides indistinguishable. Nolde even signed some of his watercolors on both the front and the back.

FLOWING COLOR

Nolde's "wet-on-wet" technique of painting gives his subject matter a striking spontaneity. It is as if he has just lifted his brush from the paper. He has allowed the brilliant blue of the background to flow onto the edges of the flowers and leaves, helping to define the darker tips of the flowers' petals.

VIBRANT WATERCOLORS

Despite their vivid coloring, Nolde's watercolors of flowers are exceptional in their tranquility. Expressionists such as Nolde are usually associated with more emotionally charged subjects. Much of Nolde's work was religious, and has been described as possessing a "particularly ferocious quality."

Into the abstract world

THE FIRST TEN YEARS of the 20th century saw a move in Western art away from the realism that had dominated since the 15th and 16th centuries, toward an approach loosely labeled "Abstraction." The advance of photography, invented in the mid-19th century, seemed to have ended the quest to represent reality. Artists began to explore form and color for their own sake, rather than depict recognizable subjects, and it was movements such as Cubism and Expressionism (pp. 58–59) that paved the way. Some of the most significant 20th-century artists have used abstract images and have found the fluid nature of watercolor ideal for producing these kinds of forms. This was evident even in the 19th century, in the freer watercolors of Turner and Cézanne (pp. 36–37, 52–53). By the 20th century, abstract artists had found new ways of using watercolor – for example, Picasso's harsh brushwork in *Head of a Woman* (below, left). Because of the medium's immediacy – any errors are difficult to correct – it is perfect for artists exploring basic shapes and colors.

HINEIN
Wassily Kandinsky; 1928;
15 x 10½ in (38.5 x 26.5 cm); watercolor
The Russian artist Kandinsky (1866–1944) often sprayed watercolor paint onto the paper with an atomizer or blow-pipe, as he has in this painting. Like many abstract artists, he experimented with mixing different media – for example, splattering the surface of a watercolor with ink to add texture and depth.

HEAD OF A WOMAN
Pablo Picasso; 1909;
12 x 9 in (30.5 x 23.5 cm);
watercolor and gouache
This is one of Picasso's early Cubist works – reality is fragmented so that objects and people are seen from different points of view at the same time. The sharp, angular strokes create the effect of pencil or crayon, unlike the fluid brushwork seen in most watercolors. Picasso has used gradations of color, and the washes have been applied over a strong linear "scaffolding."

PABLO PICASSO (1881–1973)
Picasso is considered to be one of the 20th century's most important artists. Born in Spain, he spent most of his life in France. With Georges Braque, he was an original member of the Cubist group in the early 20th century, and later became involved with Surrealism. Although much of his art was semi-abstract, it remained dominated by the human figure.

The Polychrome Flower
FERNAND LÉGER *1937;*
16½ x 23½ in (42 x 60 cm); gouache
Much of Léger's work divorces objects from their normal surroundings. Here, it is a starfish-shaped flower, painted in the strong colors possible with gouache. Léger (1881–1955) made increasing use of watercolor, especially to give planes of flat color that contrasted well with his dynamic shapes and vibrant color schemes.

Still Life with Apple

PAUL KLEE *1932; 9¾ x 12¼ in (25 x 31 cm); watercolor*

The paintings of the Swiss artist Klee (1879–1940) cannot really be linked with any specific movement. He often worked in watercolor, using the medium with great delicacy. In various works, he combined watercolor with other media, even with oils. Lines took a central role in his paintings – he wrote of "taking a line for a walk."

NORTHWEST DRIFT
Mark Tobey; 1958; 44¾ x 35½ in (113.5 x 90.5 cm); tempera and gouache
Born in Wisconsin, Tobey (1890–1976) is known as a pioneer of Abstract Expressionism. In *Northwest Drift*, the quality of the paint conveys a sense of the ocean – for much of his life, Tobey lived in Seattle, in a house near the Pacific.

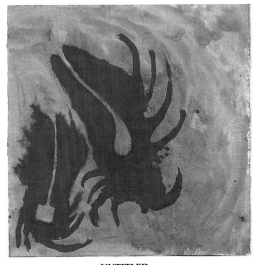

UNTITLED
Anish Kapoor; 1988; 22 x 22 in (56 x 56 cm); gouache
Many artists have found watercolor or gouache ideal for analyzing the nature of color. Kapoor's colors are limited, but each is highly significant. The Indian-born artist (b. 1954) uses color to paint the "interior ... of me." Brown washes often form a basis for his work, and red may represent bodily organs, as it does here.

Glossary

Aquatint A type of etching that reproduces the wash effects of watercolor.

Bodycolor Watercolor that has been thickened and made opaque by adding lead white. From the 19th century, Chinese white was used instead. (See also Gouache.)

Brushes Watercolor brushes were traditionally made from sable or squirrel hair. These are still used today, as is polyester. Good brushes must come to a fine point when wet, to allow detailed working of the paint.

Cakes From the late 18th century, watercolors were manufactured in cake form. Honey was added to prevent the paint from drying out.

Chinese white Zinc oxide. Used as a white pigment to make watercolor opaque.

Engraving A method of print-making. Lines are cut into a copper plate with a tool called a burin. When this plate is inked up, ink is held in the incised lines, and it is these lines that come out in the print.

Etching A process similar to engraving, except that the etcher draws on a gum- or wax-covered plate, using a metal point. The etched plate is placed in acid, which eats into the plate where it has been exposed by the metal point.

Glair A binding agent made of egg white, used particularly in medieval manuscripts. It was superseded by gum arabic.

An 1865 Winsor and Newton box for storing watercolor paints.

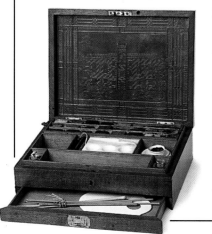

Glaze A thin layer of gum arabic applied over a watercolor. Glaze gives underlying colors an added richness and brilliance.

Gouache Watercolor that either: 1) has a high concentration of colored pigment, *or* 2) is mixed with white pigment or chalks to which gum or honey have been added. A gouache color is strong, bright, and opaque, and totally obscures the painting surface underneath. The term is often used loosely instead of bodycolor.

Medieval manuscripts, precursors of modern watercolors, were painted in bodycolor on parchment or vellum. Glair was used as a binding agent.

Ground A preparatory surface, consisting of either: 1) Chinese white, used to heighten the brilliance of colors laid over the top, *or* 2) dark washes, used to give various tonal qualities to overlaid paint.

Gum arabic The normal binding agent used in watercolor; it makes the paint adhere to the paper. It is a vegetable gum derived from the acacia tree, and, unlike other resins, is soluble in water. Gum arabic is ground up and mixed with pigments to make watercolor paints. Colors are then taken up on the brush, which has been dipped in water. When painted onto a surface, the water evaporates but the gum arabic remains, and binds the pigment to the surface.

A good brush should come to a fine point

Heightening The application of areas of gouache (usually white) to highlight features in a watercolor.

Illuminated manuscript A manuscript decorated with small illustrations, or "illuminations."

Ink Ink has often been used with watercolors to provide an outline to which watercolor is added, or as an integral part of the painting. During the Renaissance, ink was made from diseased parts of oak trees. By the 16th century, artists used carbon ink, a mix of charcoal and gum. In China and India, this was hardened by baking, and a sheen was created by adding resin.

Lead white Lead carbonate. Once used to make watercolor opaque.

Limner A 17th-century term used to describe someone who painted in opaque watercolors. It comes from the medieval Latin word *illuminare* ("to paint"). Many early miniature painters were known as limners.

Medium The word is used in various different ways: 1) A method used by artists – painting and sculpture are two different media. 2) A material – for example, oil paint or watercolor. 3) The liquid in which pigments are suspended – for example, gum and water is the medium used for watercolor.

Miniature Normally used to describe a small portrait painted in any type of watercolor. The term's origins lie in the Latin word *minium*, which means "red lead." Red lead was used as a base color by early miniaturists. In doing this, they were adopting the tradition followed by many late medieval manuscript illuminators – "miniature" can also be used to refer to a manuscript illumination.

Palette Modern watercolors are usually mixed in the cavities provided in a box of watercolor paints. Prior to this, separate palettes were used, made from objects such as mussel shells, and later from ivory.

In the later 18th century, watercolors were often mixed on ivory palettes.

Paper Paper replaced parchment as the normal painting surface for watercolors. The paper used is usually white and acts as a reflector of light through transparent washes of color. Paper is coated with either glue or starch. This coating seals the paper, preventing ink or watercolors from being soaked up like ink on blotting paper. The first papers were handmade from the fibers of boiled rags and linen. By the late 18th century, tougher hand-made papers started to appear. The 19th century saw the invention of cheaper machine-made paper.

Parchment The skin – usually from sheep, goats, or calves – used in the Middle Ages as a writing and painting surface, particularly for illuminated manuscripts.

Pigment Derived from animal, mineral, or vegetable sources,

Ground pigment pours out of a spout at the front

A "painting mill" (Winsor and Newton, about 1850), used for the grinding of pigments.

pigment gives paint its color. Ground into small particles, it is held in suspension in a binding agent such as oil (in oil paint) or gum arabic (in watercolors). When paint is struck by light, it is the pigment that gives off the particular color.

Scraping-out The creation of highlights by scraping away paint to reveal the white paper below.

Stopping-out A technique used to lighten an area of dark color. While the paint is still wet, color is lifted off – with a moist cloth, a sponge, or perhaps a piece of bread.

Tempera The term is often used to refer to paint in which pigment is mixed (tempered) with egg yolk and thinned with water. It is also applied to pigments dissolved in water and mixed with gum or glue. Today, "tempera" may be used loosely for any watery kind of paint.

Tubes Around 1847, Winsor and Newton developed the first tubes of watercolor. The paint was kept moist by adding honey or glycerine.

Underdrawing Watercolors are often sketched out first in pen or, more usually, pencil.

Vellum A fine parchment, made of young animal skins rubbed with pumice, chalk, or ground bone.

Wash An application of semi-transparent ink or watercolor, as opposed to the use of gouache or opaque bodycolor.

Watercolor The general term used to describe paints soluble in water.

Wet-on-wet Working on paper that has been deliberately damp-ened with water (or where the paint is still wet) so that colors run into one another.

Woodcut A relief print made from cutting out a design drawn onto the surface of a wooden block. When the inked block is printed onto paper, it is the cut-out areas that remain white.

Featured works

Look here to find the location of, and complete details about, the works featured in the book.

This section also includes photographic acknowledgments. Every effort has been made to trace the copyright holders, and we apologize in advance for any unintentional omissions. We would

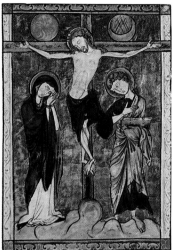

THE CRUCIFIXION, French Psalter, c.1215 (p. 11)

be pleased to insert the appropriate acknowledgment in any subsequent edition of this publication.
t: top; *b*: bottom; *c*: center; *l*: left; *r*: right

Abbreviations:
AIC: © The Art Institute of Chicago, All Rights Reserved; BAL: Bridgeman Art Library, London; BL: By permission of the British Library, London; BM: The Trustees of the British Museum, London; CM: Castle Museum, Norwich; ML: Musée du Louvre, Paris; NPG: By courtesy of the National Portrait Gallery, London; OAG: Oldham Art Gallery, Oldham, Lancashire; RIBA: The British Architectural Library, RIBA, London; RMN: Réunion des Musées Nationaux, Paris; TG: Tate Gallery, London; V&A: Courtesy of the Board of Trustees of the V&A, London; WMG: William Morris Gallery, Walthamstow, London; W&N: Winsor and Newton, Harrow, Middlesex

Front cover:
Clockwise from top left: Ivory palettes, W&N; *Standing Female Nude* (p55); *Self Portrait* (p24); watercolor box, W&N; *The Military Roll of Arms* (p8); lady's silver paint pot (p40); *Rosa Damascena* (p9); *St. John's Gospel* (p10). **Inside front flap:** *t*: *Young Man Among Roses* (p25); *b*: Egyptian tools (p6). **Back cover:** Clockwise from top left: Locket paint set and catalog (p29); *Peasant Girl with Turkeys* (p50); *Gallery of the Society of Painters in Watercolours* (p38); cake-maker (p7); *A Falcon* (p21); *Three Studies of a Helmet* (p16); portable paint set (p29); artist's taborette (p23); pigment grinder, W&N; Design for Corniche Mosque (p57); January (p12)

p1: (Half Title): Watercolor box, W&N. **p2:** *tl*: *The Ancient Pine of Dong Mon* (p19); *tr*: Detail from page of Moralized Bible (p11); *cr*: *Study of a Velvet Crab* (p14); *cr*: Design for a Single Flower of Tulip Chintz (p48); *b*: *The Bodhisattva Manjusri* (p20-1); *tc*: Gold leaf, W&N. **p3: (Title Page):** *tl*: William Blake, title pages to Young's "Night Thoughts" (p42); *tc*: St.

Germain Near Tunis (p58); *tr*: *Sir Walter Raleigh* (p24); *b*: *Peasant Girl with Turkeys* (p50-51). **p4:** *tc*: *A Monk Resisting the Attractions of Women* (p20); *cr*: *Nightmare of Demons and Chimeras* (p18); *bc*: Plan of Half of the Mosaic Cupola of Santa Costanza, Rome, (p8-9); *cl*: *Two Blue Horses in Front of a Red Rock* (p58); *tl*: Watercolor box, W&N; *bl*: Gum arabic, W&N; *tr*: Cinnabar and saffron, W&N **p5:** *The Three Bathers* (p52)

Pages 6-7 What is watercolor?
p6: *tl*: Hand and ritual markings, The Ancient Art and Architecture Collection; *cr*: Egyptian upright slab, BM; *bl*: Egyptian brushes, palettes, and pigments, BM. **p7:** *tl*: *The Ancient Pine of Dong Mon*, Gao Fengham (see p19); *bl*: *View of the Campagna, Italy*, J.M.W. Turner, TG; *br*: watercolor cake-maker, watercolor cakes and tubes, W&N; *c*: gum arabic, W&N; *tr*: Shah Tahmasb's *Nizami Manuscript*, BL

Pages 8-9 The variety of watercolor
p8: *tl*: Map of Great Britain, Matthew Paris, BL; *cr*: *The Military Roll of Arms*, BL; *cl*: *St. Ottilie*, Staatliche Graphische Sammlung, Munich; *bc*: Plan of Half of the Cupola of Santa Costanza, Rome, Pietro Santi Bartoli, RIBA. **p9:** Wimpole Hall: Front Entrance from Repton's Red Book (before & after planting proposed), Humphry Repton, © National Trust 1991, AC Cooper; *cl*: *Calais Pier*, David Cox, Spink and Son Ltd., London/BAL; *cr*: *Rosa Damascena* from *Les Roses*, Pierre-Joseph Redouté, Lindley Library RHS/BAL; *br*: Dulwich Picture Gallery, Sir John Soane, Sir John Soane's Museum, London

Pages 10-11 Illuminated texts
p10: *cl*: Beginning of St. John's Gospel, *Arnstein Bible*, BL; *br*: St. John, *Lindisfarne Gospels*, BL; *tr*: Jacob Wrestling with the Angel, *Vienna Genesis*, National Library, Vienna. **p11:** *tl*: The Crucifixion, French Psalter, Musée Marmottan, Paris; *bl*: Siege Warfare, BL; *br*: Baptism of Constantine Initial, Girolamo di Giovanni da Cremona, Musée Marmottan, Paris; *cr*: A King, a Queen and a Cleric Instructing a Secular Artist in the Writing and, Painting of a Manuscript, Moralized Bible, Pierpont Morgan Library, New York; *tr*: Vellum, W&N

Pages 12-13 The Limbourgs
p12: *Les Très Riches Heures du Duc de Berry*, *bl*: January; *tr*: Calendar for October; *bc*: February; *br*: March. **p13:** *tl*: October; *b*: The Garden of Eden, Musée Condé, Chantilly/Giraudon, Paris; *tr*: Gold leaf, W&N

Pages 14-15 Nature into art
p14: *tl*: Bramble, *Herbarium*, Apuleius Platonicus, Bodleian Library, Oxford; *bl*: *A White-Headed Parrot, Tortoise-Shell and Rock Underwing Butterflies an Oak Beauty Moth and White Muscadine Grapes*, Samuel Dixon, The National Gallery of Ireland; *cr*: *Daffodils and Red Admiral Butterfly*, Jacques le Moyne de Morgues, V&A. **p15:** *tc*: Study of a Velvet Crab, John Ruskin, Ashmolean Museum, Oxford; *bl*: Jumping Trout,

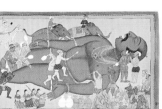

THE AWAKENING OF KUMBHAKARNA, *Sahib Din*, 1652 (p. 20)

Winslow Homer, The Brooklyn Museum New York, 41.220, In Memory of Dick S. Ramsa; *br*: W. Homer's paint box, W&N

Pages 16-17 Watercolor's first master
p16: *tr*: Self Portrait, Albrecht Dürer, Alte Pinakothek, Munich; *c*: Three Studies of a Helmet, Dürer, ML, RMN; *cl*: *A Weierhaus*, Dürer, BM; *cr*: Stag Beetle, Dürer, Collection of the J. Paul Getty Museum, Malibu, California; *bl*: Dream Vision, Dürer, Kunsthistorisches Museum, Vienna. **p17** *View of the Val d'Arco, Tyrol*, Dürer, ML, RMN

Pages 18-19 Eastern approaches
p18: *c*: Animals and Their Uses, BL; *bl*: Shah Tahmasb's *Nizami Manuscript*, BL; *r*: *Nightmare of Demons and Chimeras*, Kawanabe Nobuyuki ("Kyosai"), BM. **p19:** *t*: The Ancient Pine of Dong Mon, Gao Fengham, BM; *br*: Portrait of Cai Shiying, BM; *bl*: Two Popular Ethiopian Saints, BL; *bl*: The Adventures of Prince Panji, BL

Pages 20-21 The art of India
p20: *t*: The Bodhisattva Manjusri, BL; *c*: A Monk

Resisting the Attractions of Women, V&A; *bl*: Akbar's Triumphant Entry into Surat, V&A; *cr*: The Awakening of Kumbhakarna, Sahib Din, BL. **p21:** *tl*: The Toils of Love, BL; *cr*: A Falcon or Peregrine, BL; *cl*: The Book of Creation, BL

Pages 22-23 Miniature painting
p22: *tr*: Mrs Pemberton, Hans Holbein, V&A; *cr*: Hans Holbein, Lucas Hornebolte, Wallace Collection; *bl*: The Family of Sir Thomas More, Rowland Lockey, V&A. **p23:** *tl*: Baroness Burdett-Coutts, William Charles Ross, NPG; *cr*: Sir Thomas Stepney, George Engleheart, V&A; *br*: William Grimaldi at His Writing Desk, Mary Grimaldi, after Louisa Edwards, NPG; *br*: Artist's taborette for painting miniatures, W&N

Pages 24-25 Portrait of an era
p24: *tr*: Self Portrait, Nicholas Hilliard, V&A; *cr*: The Heneage ("Armada") Jewel, Hilliard, V&A; *bl*: George Clifford, Hilliard, National Maritime Museum Library, London; *br*: Sir Walter Raleigh, Hilliard, NPG **p25:** *Young Man Among Roses*, Hilliard, V&A; *tr*: Mussel shell, W&N

Pages 26-27 Exploring new worlds
p26: *tr*: World map; *br*: Eskimo Woman and Child, John White, BM; *cl*: Livingstone's compass, Royal Geographical Society, London; *bl*: The Village of Pomeiooc, John White, BM. **p27:** *t*: A Prospect of the Land and Forts... Before Tangier, Wenzel Hollar, BM; *cl*: Chinese Barges of Lord Macartney's Embassy Preparing to Pass under a Bridge, William Alexander, BM; *cr*: Colonnes du Temple de Zeus Olympien, Athène, Dominique Papety, ML/ RMN; *br*: The Theater at Miletus, William Pars, BM; *bc*: Hooker's Pouch, Royal Geographical Society, London

Pages 28-29 The portable art
p28: *tl*: Watercolor box, W&N **p29:** *tr*: An Artist Traveling in Wales, Thomas Rowlandson, BM; *cr*: Messieurs les Voyageurs in a Snow Drift upon Mount Tarrar, J.M.W. Turner, BM; *bc*: Ruins of Paestum near Salerno: The Three Temples, John Robert Cozens, OAG. **p29:** *t*: Tivoli From Below the Waterfalls, Francis Towne, BM; *cl*: Eugène Delacroix, Page from Album du Maroc, ML/RMN; *c*: Portable paint set, W&N; *br*: W&N catalog and locket paint set, W&N

Pages 30-31 Satirical images
p30: *cl*: Sketching a Country Woman, Thomas Rowlandson, Museum of New Zealand, Te Papa Tongarewa, Wellington, NZ; *tr*: George III and Napoleon, James Gillray, Mary Evans Picture Library; *bc*: John Bull and his Family Taking Leave of the Income Tax, Roberts, Neil McCann. **p31:** *tr*: Two Drinkers, Honoré Daumier, Christie's Color Library; *tl*: Le Désaccord, Alexandre Gabriel Decamps, ML/RMN; *c*: Caricature Portrait of the Political Journalist Henri Rochefort, Alfred Le Petit, Bachollet, Paris; *br*: Maggie Thatcher, David Lewis; *bl*: Sir Cecil Harcourt Smith Receives a Deputation from a Northern Town That is Meditating a Museum, Sir Max Beerbohm, V&A

Pages 32-33 The British tradition
p32: *tl*: John Constable, Daniel Maclise, NPG; *c*: Folkestone Harbor with a Rainbow, John Constable, BM. **p33:** *tl*: Monument to Perpetuate the Fame of British Artists, James Prinsep, BM; *tr*: Kirkstall Abbey, Yorkshire, Thomas Girtin, V&A; *bl*: The Night Train, David Cox, Birmingham Museum and Art Gallery; *cr*: Landscape, John Martin, OAG

Pages 34-35 Cotman – a sense of place
p34: *tl*: Portrait of John Sell Cotman after J.P. Davis, Mrs. Dawson Turner, CM; *bl*: Devil's Elbow, Rokeby Park, Cotman, CM; *br*: Greta Bridge, Cotman, CM. **p35:** *br*: Storm on Yarmouth Beach, Cotman, CM; *tc*: Greta Bridge, Cotman, BM; *bl*: Yarmouth Beach During a Storm from In and About Ancient Yarmouth, Norfolk County Council Library and Information Service/Photo: Brian Ollington

Pages 36-37 Turner and landscape
p36: *tl*: Turner's House, Cheyne Walk, NPG/Photo: Emery Walker; *cl*: Turner Painting

One of his Pictures, Richard Doyle, NPG; *tr*: J.M.W. Turner, C. Martin, NPG; *cl*: Imaginary Landscape with Windsor Castle, Turner, TG. **p37:** *tl*: The Sun Setting Amongst Clouds, Turner, TG *br*: Turner, TG; *br*: The Old Devil's Bridge, Pass of St. Gothard, Turner, TG; *c*: View of the Campagna (p7); *tr*: Turner's palette and traveling case, TG

Pages 38-39 Exhibition works
p38: *tl*: Exhibition medals, W&N; *bl*: A Village Snow Scene, Robert Hills, Yale Center for British Art, Paul Mellon Collection; *tr*: Gallery of the Society of Painters in Watercolours, Thomas Rowlandson, BM; *br*: L'Escalier du Musée, Jean-Baptiste Isabey, ML/RMN/Giraudon. **p39:** *tl*: Stonehenge, John Constable, V&A; *cl*: The Thames at Isleworth, John Glover, Yale Center for British Art; *bc*: A Frank Encampment in the Desert of Mt. Sinai 1842, John Frederick Lewis, Yale Center for British Art, Paul Mellon Collection; *cl*: W&N watercolor box, W&N

STONEHENGE, *John Constable*, 1836 (p. 39)

Bristol Museum and Art Gallery; *tr*: Camera obscura, Science Museum, London

Pages 40-41 A genteel pursuit
p40: *tr*: Man With a Claude Glass, Thomas Gainsborough, BM; *tl*: Archibald Robertson's Trade Card, BM; *cl*: Lady's silver paint pot; *bc*: Two Young Women Drawing Amidst Classical Ruins, Hubert Robert, ML/RMN. **p41:** *tl*: Scene in Wales, Rev. Thomas Gisborne, BM; *cr*: Sketching Party in Leigh Woods, Samuel Jackson,

Pages 42-43 The "mystics"
p42: *tl*: Drawing of William Blake, Hulton Deutsch Collection; *cl*: (left) Illustration to Young's "Night Thoughts," Night III, title page, (right) illustration to Young's "Night Thoughts," Night VIII, Narcissa, William Blake, BM/BAL; *tr*: Mildew Blighting Ears of Corn, William Blake, National Trust, Petworth/BAL; *br*: Jacob's Dream,

ODALISQUE, *J.D. Ingres*, 1864 (p. 54)

William Blake, BM; *bl*: The Herdsman, Samuel Palmer, OAG **p43:** *tl*: Port Stragglin, Richard Dadd, BM; *br*: Phaeton, Gustave Moreau, ML/RMN; *bl*: The Primitive City, Edward Calvert, BM

Pages 44-45 Book illustrations
p44: *cl*: Cinderella, BL; *bl*: Illustration from Oliver Twist, George Cruikshank, BM; *br*: Heathcliff from Wuthering Heights, Edmund Dulac, Sotheby's; *br*: Girl and Two Babies, Kate Greenaway, V&A **p45:** *cl*: Thumbelina, Joan Charleton, Sotheby's; *tr*: Treasure Island, Salomon von Abbé, Sotheby's; *tl*: Winnie the Pooh, Line Illustration from WINNIE-THE-POOH, copyright E.H. Shepard under the Berne Convention. In the U.S.

Continued on p. 64

Index

Continued from p. 63

copyright 1926 by E.P. Dutton, copyright renewal 1954 by A.A.Milne. Coloring-in copyright © 1973 by E.H.Shepard and Methuen Children's Books Ltd. Reproduced by permission of Curtis Brown Ltd, London; br: Pop-up Rupert Bear, Photo: R.Kemp, by kind permission of Express Newspapers plc

Pages 46-47 The Pre-Raphaelites
p46: cl: The Mill on the Thames at Mapledurham, George Price Boyce, Fitzwilliam Museum, Cambridge; tr: Horatio Discovering the Madness of Ophelia, Dante Gabriel Rossetti, OAG; b: Chaffinch Nest and May Blossom, William Henry Hunt, Courtauld Institute Galleries, London; tc: Lewis Carroll, Rossetti Family, NPG. **p47:** tl: Phyllis and Demophoön, Sir Edward Coley Burne-Jones, Birmingham Museum and Art Gallery; tr: Sir Edward Coley Burne-Jones, photo: Barbara Leighton, NPG; cr: The Painter's Pleasure, Simeon Solomon, Whitworth Gallery, University of Manchester; br: The Holy City, William Holman Hunt, OAG

Pages 48-49 A company of craftsmen
p48: tr: Portrait of William Morris, Cosmo Rowe, National Trust Photographic Library/Derrick E. Witty, Wightwick Manor; cl: Trellis Wallpaper Design, WMG; bl: Piece of Tulip Chintz and Printing Block, WMG; br: Design for Single Flower of Tulip Chintz, WMG. **p49:** Design for Pomona Tapestry, National Trust Photographic Library/Derrick E.Witty, Wightwick Manor, West Midlands

Pages 50-51 Impressionism
p50: tl: Study of Woman of Algiers, Eugène Delacroix, ML/RMN; bc: Peasant Girl with Turkeys, Camille Pissarro, Brooklyn Museum, 59.28, gift of Mrs. Edwin C.Vogel/Brooklyn Museum Collection; tr: Portrait of Berthe Morisot, Edouard Manet, Helen Regenstein

Collection, 1963.812, AIC; bl: Carriage in the Bois de Boulogne, Berthe Morisot, Ashmolean Museum, Oxford. **p51:** t: Landscape Near La Côte Saint André, J.B. Jongkind, BM; c: Gondoliers at Venice, J.L.E. Meissonier, ML, RMN; br: Tahitian Landscape, Paul Gauguin, ML/RMN;

Pages 52-53 Cézanne – art and light
p52: tl: Photograph of Cézanne, Bibliothèque Nationale, Paris; tr: Man Wearing a Straw Hat, Paul Cézanne, gift of Janis Palmer in memory of Pauline K. Palmer 1983.1498, AIC; bl: The Three Bathers, Cézanne, National Museum of Wales, Cardiff; br: Mont Ste. Victoire, Cézanne, Courtauld Institute Galleries, London. **p53:** Still Life with Apples, Bottles, and Chairback, Cézanne, Courtauld Institute Galleries, London

Pages 54-55 The nude in watercolor
p54: cl: Painting Under Difficulties,Thomas Rowlandson, National Gallery of Scotland; tr: Odalisque, J.D. Ingres, Musée Bonnat, Bayonne; b: Les Deux Amies, Jules-Robert Auguste, ML, Cabinet des Dessins/RMN **p55:** tl: Standing Female Nude, Paul Cézanne, ML, Cabinet des Dessins/RMN; tr: Reclining Female Nude, Oskar Kokoschka, Graphische Sammlung, Albertina, Vienna © DACS 1993; br: Neptune, Auguste Rodin, Musée Rodin, Paris; photo: Bruno Jarret, © ADAGP, Paris and DACS; London 1993; bl: Auguste Rodin, photo: G.C. Beresford, NPG

Pages 56-57 Modern uses of the medium
p56: cl: Design for a Nursery Chintz, Charles Voysey, RIBA; bc: Stage Design for Comte Ory, Glyndebourne, Oliver Messel,V&A Theater Museum, reproduced by kind permission of Lord Snowdon. **p57:** tl: Design for Corniche Mosque, Abdel Wahed El-Wakil, El-Wakil Associates; tr: Kent, Garden of Eden, Frank Sherwin, reproduced by kind permission of the keeper of the National Railway Museum, York; cr: Cloak from Hansel and Gretel, Roger A. Oakes, costume design by Terry Frances Parr,

reproduction courtesy of Welsh National Opera, photo: Kurt Vickery; br: Fashion design, Emma Mandell-Lynn

Pages 58-59 Expressionism
p58: tl: Photograph of Cézanne, Egon Schiele, gift of Dr. Eugene Solow in memory of Gloria Blackstone Solow, 1966.172 recto, photograph by Kathleen Culbert-Aguilar, Chicago, © 1992 AIC; bl: Das Paar, George Grosz, Christie's Color Library © DACS 1993; cr: St. Germain Near Tunis, August Macke, Städtische Galerie im Lenbachhaus, Munich; tr: Two Blue Horses in Front of a Red Rock, Franz Marc, Städtische Galerie im Lenbachhaus, Munich. **p59:** Sunflowers, Emil Nolde, Visual Arts Library

Pages 60-61 Into the abstract world
p60: cl: Head of a Woman, Pablo Picasso, gift of Mr. and Mrs. Roy J. Friedman, 1964.215, photograph by Kathleen Culbert-Aguilar, Chicago, photograph courtesy of AIC, © DACS 1993; bl: Photograph of Picasso, Hulton Deutsch Collection; cr: La Fleur Polychrome, Fernand Léger, Musée des Beaux Arts, Lyon © DACS 1993; tr: Hinein, Wassily Kandinsky, Sprengel Museum, Hannover, © ADAGP, Paris and DACS, London 1993. **p61:** t: Stilleben mit dem Apfel, Paul Klee, Christie's Color Library, © DACS 1993; bl: Northwest Drift, Mark Tobey, TG © DACS 1993; br: Untitled, Anish Kapoor, TG

Pages 62-63 Glossary
p62: tl: Moralized Bible (see p11); bl: Watercolor Box, W&N tr: Pigment Grinder, c: Ivory Palettes, W&N. **p63:** tl: The Crucifixion, French Psalter (see p11); br: Odalisque, J.D.Ingres (see p54); tr: Stonehenge, John Constable (see p39); bl: The Awakening of Kumbhakarna, Sahib Din (see p20)

Acknowledgments

Dorling Kindersley would like to thank: Winsor & Newton for allowing us to photograph at its museum in Harrow, Middlesex; and the staff at Winsor & Newton who answered our innumerable questions; the William Morris Gallery, Walthamstow, London, which allowed us to photograph its collection; Alan Brett Ltd, for giving us permission to photograph its maps; Greg Martin, for taking an interest in the book and providing us with information about his map; Neil McCann, for kindly lending us his Roberts' print; Hilary Bird, for preparing the index.

Thanks are also due to the following members of the Eyewitness Art Team: Margaret Chang, Sandra Copp, Gwen Edmonds, Sean Moore, Toni Rann, Job Rabkin, and Tina Vaughan; a special thank you goes to: Louise Candlish, Mark Johnson-Davies, Phil Hunt, Laura Harper, Stephanie Jackson, and Constance Novis for their help and exceptional kindness.

A special thank you is also due to Julia Harris-Voss, for her work on additional picture research, and for her unerring support throughout the project.

Author's acknowledgments:
I would like to thank the following people for their invaluable help on this book: Helen Castle, Laura Harper, Ann Kay, and Claire Pegrum; and I would like to dedicate this book to my children: Alexander, Oliver, and Emily.